T0035882

THE NOTEBOOKS OF
LEONARDO
DA VINCI

THE NOTEBOOKS OF
LEONARDO
DA VINCI

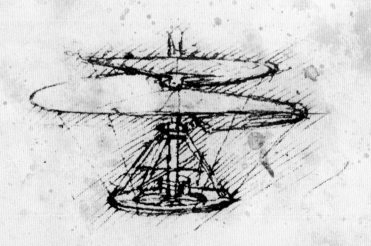

SIRIUS

SIRIUS

This edition published in 2022 by Arcturus Publishing Limited
26/27 Bickels Yard, 151–153 Bermondsey Street,
London SE1 3HA

Copyright © Arcturus Holdings Limited

All rights reserved. No part of this publication may be reproduced,
stored in a retrieval system, or transmitted, in any form or by
any means, electronic, mechanical, photocopying, recording or
otherwise, without prior written permission in accordance with the
provisions of the Copyright Act 1956 (as amended). Any person or
persons who do any unauthorised act in relation to this publication
may be liable to criminal prosecution and civil claims for damages.

ISBN: 978-1-3988-2501-7
AD005681UK

Printed in China

Contents

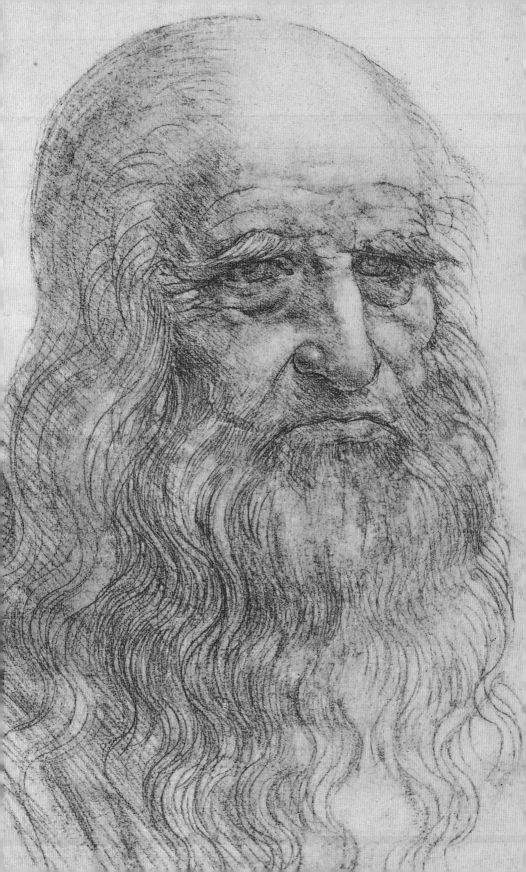

Introduction

'The noblest pleasure is the joy of understanding.'

Leonardo da Vinci

No one embraced this sentiment better than Leonardo
da Vinci himself. Today, archives around the world hold
in excess of 4,000 pieces of paper, many loosely collected
into 'notebooks' or 'manuscripts', with the observations,
sketches, studies and thoughts of a man who was not
just an artist but an engineer and a student of anatomy,
science, music, theatre production and much more.

 The sheer scope of Leonardo's interests is impressive;
given his background, his hunger to learn is all the
more remarkable. Leonardo di ser Piero da Vinci is
believed to have been born, in 1452, in a farmhouse
near the village of Anchiano, in the hills above the
town of Vinci, about 22 miles (35 km) from Florence.
His father, Ser Piero da Vinci, was a notary in Florence,
his mother a peasant girl called Caterina. Although his
parents were not married, Leonardo was welcomed into
his father's household and divided his time between the
bustling streets of Florence and the countryside where
his mother's family farmed. He loved the views across
the Tuscan hills, and the earliest drawing attributed to
him, dated 5 August 1473, is of a landscape entitled
View towards Monsummano. It was the start of a life-
long fascination with perspective and light.

 Somewhere between the ages of ten and 14,
Leonardo became an apprentice in the workshop of

the Florentine artist Andrea del Verrocchio. He learned to read and write, but his education was insufficient to allow him to attend university. In Verrocchio's studio, he learned how to mix paints, to prepare wooden panels for painting, and various techniques, such as metalpoint.

In 1472, Leonardo's name was entered in the account book of the Compagnia di San Luca in Florence (the organization of painters): he was now a professional artist. His first autonomous painting is considered to be *The Annunciation* (c. 1472–73), which demonstrates an impressive awareness of perspective in its composition.

The young man was inquisitive and perspicacious. In conjunction with seeking commissions for paintings – as did many Renaissance artists – he pursued interests in a variety of areas from architecture to astronomy and flight. Given the political turmoil of the states into which Italy was then divided and of Europe as a whole, he was very aware of the threat of war and that rulers of the Italian states, such as Ludovico Sforza, for whom he would work when he moved to Milan, would welcome any military advantage through new inventions. Thus, Leonardo's jottings and designs contain myriad ideas for tanks, crossbows and other weapons, as well as flying machines and forts.

By 1483, Leonardo had established himself in Milan as a painter, but he sought work from Ludovico Sforza, writing a letter to him that offered his services and listed his talents, explaining how he was eminently qualified to build a large bronze commemorative statue of Ludovico's father Francesco on a horse, as well as create everything from cannon to trebuchets, bridges

and vehicles that could break through the ranks of enemy armies while protecting those inside. Although he got as far as making a huge plaster example of the equestrian statue, the actual piece was never realised. In a way, this is unsurprising. Leonardo had a tendency to spread himself across many projects. He produced plans for a redesign of the city of Milan and spent time in Pavia studying geometry and other topics of which architects needed a working knowledge. In addition, he began an ambitious programme of treatises on anatomy and painting. Fragments of the latter, dating to around 1490, still exist, and other notes, such as those reflecting Leonardo's thoughts on proportions, best exemplified by his drawing of *Vitruvian Man*, show the depth of his research. All his notes feature the famous 'mirror' script, now known to be not for security but simply a consequence of his left-handedness.

Alongside these plans and studies, he undertook painting commissions, such as the *Virgin of the Rocks* (now in the Louvre) for the Confraternity of the Immaculate Conception at San Francesco Grande in Milan. This was begun in 1483.

A decade or so later, Leonardo accepted another commission, to paint a mural of the Last Supper on the refectory wall for the Dominican monks of Santa Maria delle Grazie, also in Milan. A perspective study of the work shows how carefully the composition has been constructed. Using string radiating from the central figure of Christ, or rather the vanishing point just beside his right temple that indicates the centre of his brain, Leonardo plotted the ends of the table and ceiling coffer columns; from those he went on to work

out the proportions of the tapestries behind the figures as they recede into the background. Not only does *The Last Supper* show how much he had learned about perspective and proportion, but it and the numerous studies of heads, hands and figures in his notebooks also attest to the pains taken to give each figure character and movement. Each hand gesture and look is the result of Leonardo's powers of observation of everyday life.

Early in 1500, he journeyed to Rome and other cities, and two years later was named as 'family architect and general engineer' for the areas of Le Marche and Romagna by Cesare Borgia, then Captain-General of the Papal Armies. However, Leonardo was living in Florence, and in 1503, the Florentine Republic commissioned him to produce ideas for military machines. In the same year, he also began work on his most famous painting, the *Mona Lisa*. He continued this for a number of years and it showcases the height of his skills as a painter of the natural form. Its original Italian title, *La Gioconda*, is an amalgamation of the subject's name – Lisa Gheradini del Giocondo – and the word *madonna* (madam), and can also be translated as 'the amused one'. Leonardo took it with him when he moved to France in 1516. But after his death, the timeline of the *Mona Lisa*'s whereabouts is patchy; it seems that it stayed in Fontainebleau for the best part of two centuries before moving to Versailles, after which its next appearance is on Napoleon's bedroom wall, where it hung between 1800 and 1804.

In the final decade of his life, Leonardo returned to his treatises. He made an effort to draw together his notes on anatomy and the dissections he had witnessed.

In 1509, he even took part in the dissection of a
100-year-old man at the hospital of Santa Maria Nuova
in Florence and made detailed drawings of the organs of
a woman, as well as a series depicting the cardiovascular
system. He moved again: first to Rome, where he lived
in the home of Giuliano de'Medici, brother of Pope
Leo X; and then, in 1516, he was invited to become
peintre du roy to King François I of France, and set up
home there in Cloux near Amboise.

François was fascinated by Leonardo – as Benvenuto
Cellini observed on a visit – and paid him and his
assistants handsome salaries. In return, Leonardo was as
industrious as ever, working on projects that included
landscape plans for a chateau at Romorantin near
Blois, a canal scheme for the Sologne and various
entertainments for festivities, such as those held to
celebrate the wedding of François's niece Maddalena de
la Tour d'Auvergne to Lorenzo de'Medici.

In early 1519, however, Leonardo fell ill. He made
his will in April before dying on 2 May at Cloux.

Leonardo da Vinci's legacy is incalculable, despite the
fact that there are many works of which there is now
no trace, such as his painting of *Leda and the Swan* and
his mural of the *Battle of Anghiari* in the council hall of
the Palazzo della Signoria in Florence. Yet a significant
array survives, and the collection of extracts from his
notebooks shown here highlights the vast variety of his
interests, divided into three sections: Art, Science and
Designs. Leonardo is often described as a man ahead
of his time, and his opinions, techniques and designs, as
revealed here, are truly astonishing when one considers
that they were produced some 500 years ago.

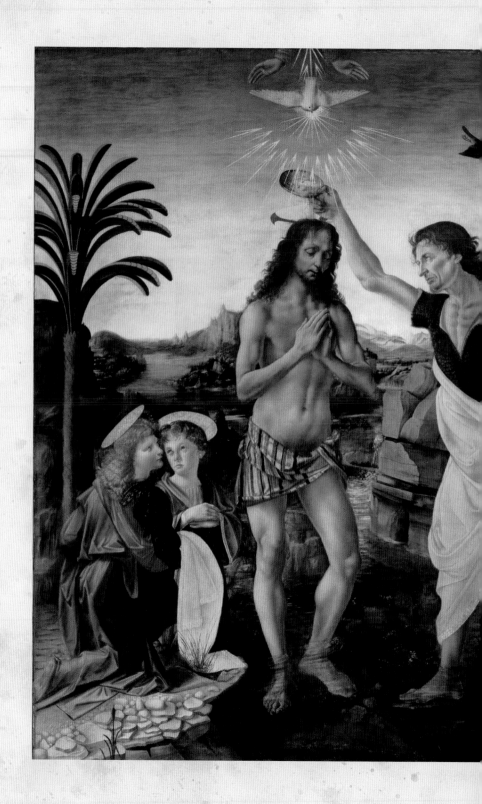

Art

Leonardo's notebooks contained a plethora of his thoughts on art – general opinions as well as practical advice. Topics ranged from choice of subjects to technical detail on how to use *sfumato* shading and perspective to create lifelike painting. In art as in all fields, he emphasised the need for continual learning. He believed, too, that art could not be separated from science – to draw a man, one needed an understanding of anatomy; to portray shadows, one must understand optics. The notebooks also offer insights into his masterworks such as the *Mona Lisa* and *The Last Supper*.

How the Mirror Is the Master of Painters: Codex Ashburnham, Manuscript 2038, 24 verso

When you wish to see whether the general effect of your picture corresponds with that of the object represented after nature, take a mirror and set it so that it reflects the actual thing, and then compare the reflection with your picture, and consider carefully whether the subject of the two images is in conformity with both, studying especially the mirror. The mirror ought to be taken as a guide – that is, the flat mirror – for within its surface substances have many points of resemblance to a picture; namely, that you see the picture made upon one plane showing things which appear in relief, and the mirror upon one plane does the same. The picture is one single surface, and the mirror is the same.

The picture is intangible, inasmuch as what appears round and detached cannot be enclosed within the hands, and the mirror is the same. The mirror and the picture present the images of things surrounded by shadow and light, and each alike seems to project considerably from the plane of its surface. And since you know that the mirror presents detached things to you by means of outlines and shadows and lights, and since you have moreover amongst your colours more powerful shadows and lights than those of the mirror, it is certain that if you but know well how to compose your picture it will also seem a natural thing seen in a great mirror.

Of Judging Your Own Picture: Codex Ashburnham, Manuscript 2038, 28 recto

We know well that mistakes are more easily detected in the works of others than in one's own, and that oftentimes while censuring the small faults of others you will overlook your own great faults. In order to avoid such ignorance, make yourself first of all a master of perspective, then gain a complete knowledge of the proportions of man and other animals, and also make yourself a good architect, that is in so far as concerns the form of the buildings and of the other things that are upon the earth, which are infinite in form; and the more knowledge you have of these the more will your work be worthy of praise; and for those things in which you have no practice, do not disdain to draw from nature. But to return to what has been promised above, I say that when you are painting you should take a flat mirror and often look at your work within it, and it will then be seen in reverse, and will appear to be by the hand of some other master, and you will be better able to judge its faults than in any other way.

It is also a good plan every now and then to go away and have a little relaxation; for then when you come back to the work your judgment will be surer, since to remain constantly at work will cause you to lose the power of judgment.

It is also advisable to go some distance away, because then the work appears smaller, and more of it is taken in at a glance, and a lack of harmony or proportion in the various parts and in the colours of the objects is more readily seen.

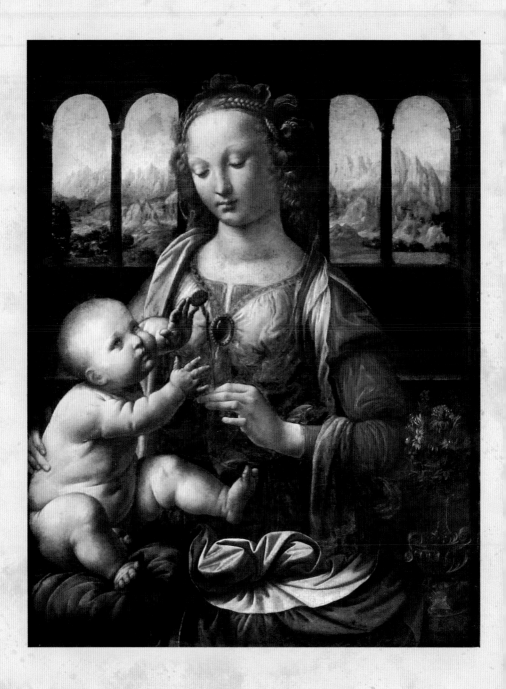

Codex Ashburnham, Manuscript 2038, 2 recto

The mind of the painter should be like a mirror, which always takes the colour of the thing that it reflects, and which is filled by as many images as there are things placed before it. Knowing therefore that you cannot be a good master unless you have a universal power of representing by your art all the varieties of the forms which nature produces – which indeed you will not know how to do unless you see them and retain them in your mind – look to it, oh painter, that when you go into the fields you give your attention to the various objects, and look carefully in turn first at one thing and then at another, making a bundle of different things selected and chosen from among those of less value. And do not follow the ways of some painters who, when tired by imaginative work, lay aside their task and take exercise by walking in order to find relaxation, keeping, however, such weariness of mind as prevents them either seeing or being conscious of different objects; so that often when meeting friends or relatives, and being saluted by them, although they may see and hear them, they know them no more than if they had met only so much air.

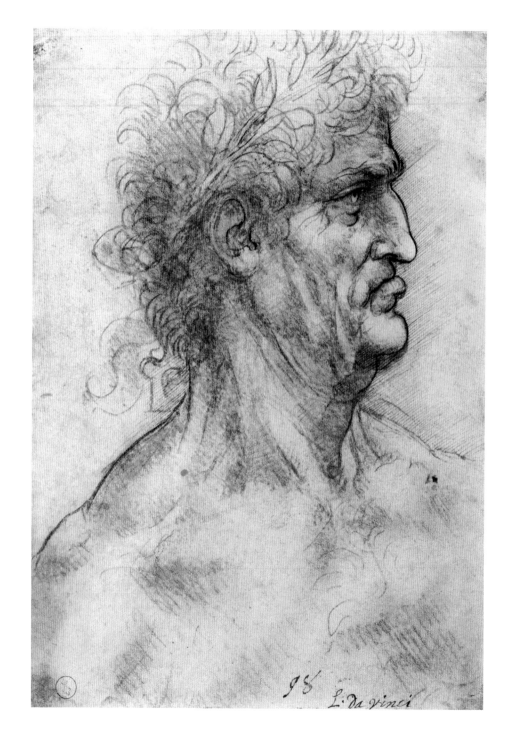

Of the Way to Fix in Your Mind the Form of a Face: Codex Ashburnham, Manuscript 2038, 26 verso

If you desire to acquire facility in keeping in your mind the expression of a face, first learn by heart the various different kinds of heads, eyes, noses, mouths, chins, throats, and also necks and shoulders. Take as an instance noses – they are often types: straight, bulbous, hollow, prominent either above or below the centre, aquiline, regular, simian, round and pointed. These divisions hold good as regards profile. Seen from in front, noses are of twelve types: thick in the middle, thin in the middle; with the tip broad, or narrow; broad, or narrow, at the base; with nostrils broad or narrow, or high or low; and with the openings either visible or hidden by the tip. And similarly you will find variety in the other features; of which things you ought to make studies from nature and so fix them in your mind. Or when you have to draw a face from memory, carry with you a small notebook in which you have noted down such features, and then when you have cast a glance at the face of the person whom you wish to draw you can look privately and see which nose or mouth has a resemblance to it, and make a tiny mark against it in order to recognise it again at home. Of abnormal faces I here say nothing, for they are kept in mind without difficulty.

Codex Forster II, 62 verso and 63 recto

One who was drinking and left the cup in its place and turned his head towards the speaker.

Another twists the fingers of his hands together and turns with stern brows to his companion.

Another, with hands opened showing their palms, raises his shoulders towards his ears and gapes in astonishment.

Another speaks in the ear of his neighbour, and he who listens turns towards him and gives him his ear, holding a knife in one hand and in the other the bread half divided by this knife.

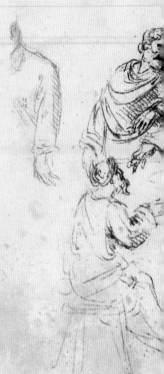

Another as he turns holding a knife in his hand overturns with this hand a glass on the table.

Another rests his hands upon the table and stares.

Another breathes heavily with open mouth.

Another leans forward to look at the speaker and shades his eyes with his hand.

Another draws himself back behind the one who is leaning forward and watches the speaker between the wall and the one who is leaning.

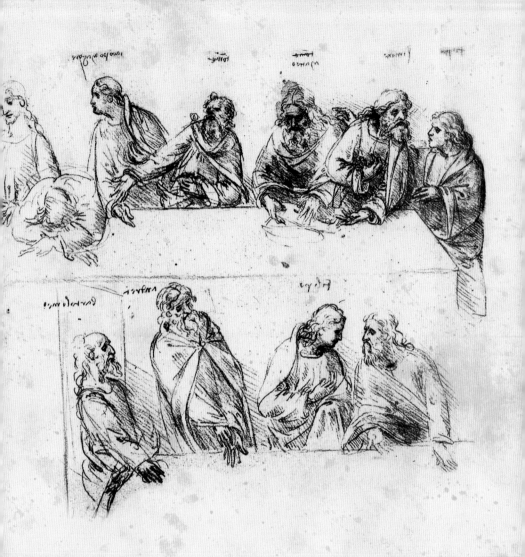

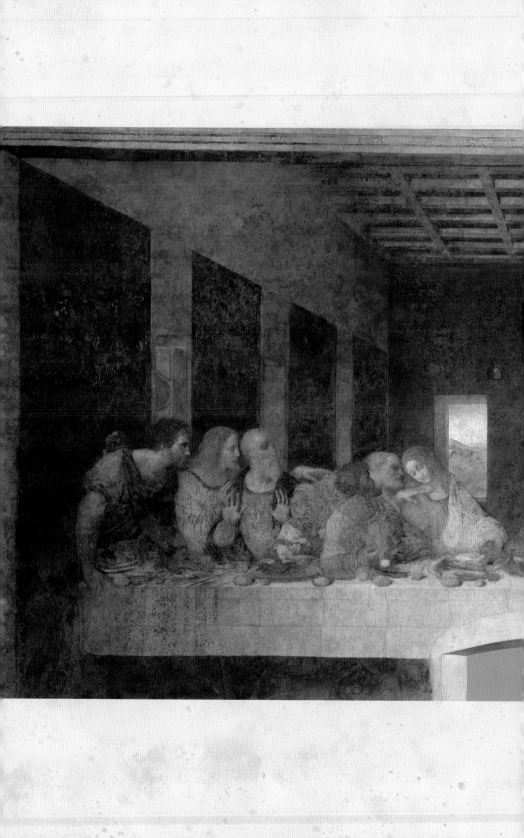

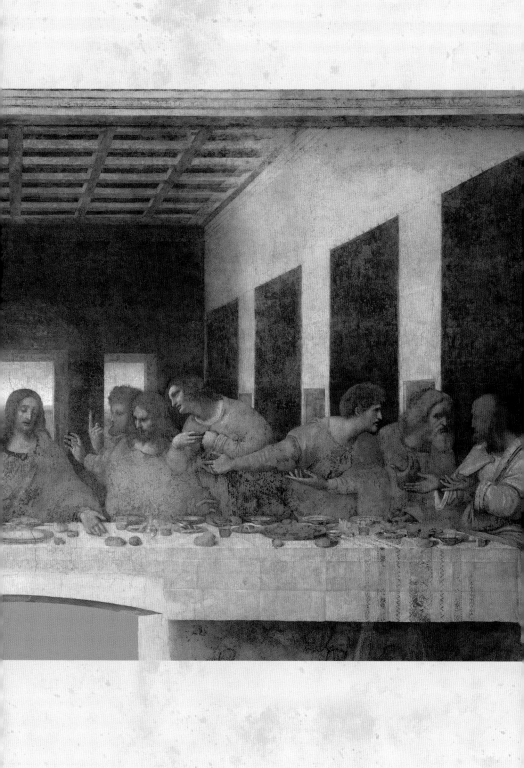

Codex Ashburnham, Manuscript 2038, 22 verso

Linear perspective has to do with the function of the lines of sight, proving by measurement how much smaller is the second object than the first and the third than the second, and so on continually until the limit of things seen. I find by experience that if the second object is as far distant from the first as the first is from your eye, although between themselves they may be of equal size, the second will seem half as small again as the first; and if the third object is equal in size to the second, and it is as far beyond the second as the second is from the first, it will appear half the size of the second; and thus by successive degrees at equal distances the objects will be continually lessened by half, the second being half the first – provided that the intervening space does not amount to as much as twenty *braccia*; for at the distance of twenty *braccia* a figure resembling yours will lose four-fifths of its size, and at a distance of forty *braccia* it will lose nine-tenths, and nineteen-twentieths at sixty *braccia*, and so by degrees it will continue to diminish, when the plane of the picture is twice your own height away from you, for if the distance only equals your own height there is a great difference between the first set of *braccia* and the second.

Discourse on Painting: Manuscript G, 53 verso

Perspective as it concerns Painting is divided into three
chief parts, of which the first treats of the diminution
in the size of bodies at different distances. The second is
that which treats of the diminution in the colour of these
bodies. The third is the gradual loss of distinctness of the
forms and outlines of these bodies at various distances.

Perspective employs in distances two opposite
pyramids, one of which has its apex in the eye and its
base as far away as the horizon. The other has the base
towards the eye and the apex on the horizon. But the
first is concerned with the universe, embracing all the
mass of the objects that pass before the eye, as though a
vast landscape was seen through a small hole, the number
of the objects seen through such a hole being so much
the greater in proportion as the objects are more remote
from the eye; and thus the base is formed on the horizon
and the apex in the eye, as I have said above.

The second pyramid has to do with a peculiarity
of landscape, in showing itself so much smaller in
proportion as it recedes farther from the eye; and this
second instance of perspective springs from the first.

In every figure placed at a great distance you lose first
the knowledge of its most minute parts, and preserve
to the last that of the larger parts, losing, however, the
perception of all their extremities; and they become oval
or spherical in shape, and their boundaries are indistinct.

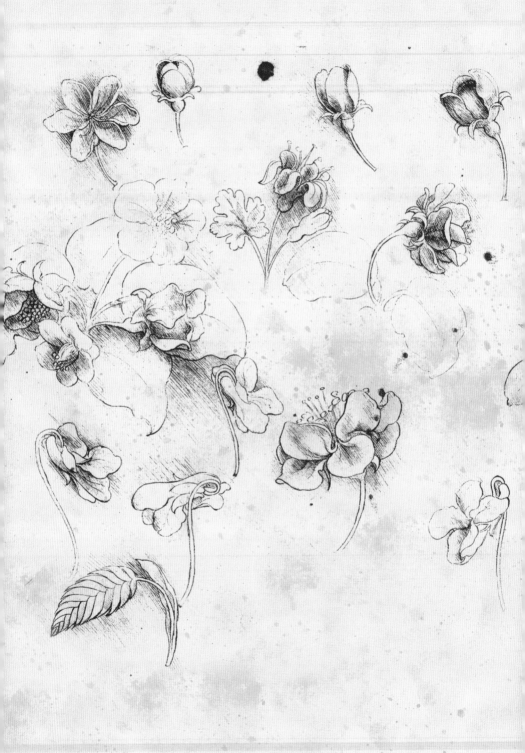

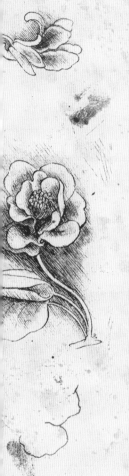

How One Ought First to Learn Diligence Rather Than Rapid Execution: Codex Ashburnham, Manuscript 2038, 27 verso

If as draughtsman you wish to study well and profitably, accustom yourself when you are drawing to work slowly, and to determine between the various lights, which possess the highest degree and measure of brightness, and similarly as to the shadows, which are those that are darker than the rest, and in what manner they mingle together, and to compare their dimensions one with another; and so with the contours to observe which way they are tending, and as to the lines what part of each is curved in one way or another, and where they are more or less conspicuous and consequently thick or fine; and lastly to see that your shadows and lights may blend without strokes or lines in the manner of smoke. And when you shall have trained your hand and judgment with this degree of care it will speedily come to pass that you will have no need to take thought thereto.

The Way to Represent a Battle: Codex Ashburnham, Manuscript 2038, 30 verso and 31 recto

Show first the smoke of the artillery mingled in the air
with the dust stirred up by the movement of the horses
and of the combatants. This process you should express as
follows: the dust, since it is made up of earth and has weight,
although by reason of its fineness it may easily rise and
mingle with the air, will nevertheless readily fall down again,
and the greatest height will be attained by such part of it as
is the finest, and this will in consequence be the least visible
and will seem almost the colour of the air itself.

The smoke which is mingled with the dust-laden air
will as it rises to a certain height have more and more the
appearance of a dark cloud, at the summit of which
the smoke will be more distinctly visible than the dust. The
smoke will assume a bluish tinge, and the dust will keep its
natural colour. From the side whence the light comes this
mixture of air and smoke and dust will seem far brighter
than on the opposite side.

As for the combatants, the more they are in the midst of
this turmoil the less they will be visible, and the less will be
the contrast between their lights and shadows.

You should give a ruddy glow to the faces and the
figures and the air around them, and to the gunners and
those near to them, and this glow should grow fainter
as it is farther away from its cause. The figures which are
between you and the light, if far away, will appear dark
against a light background, and the nearer their limbs
are to the ground the less will they be visible, for there
the dust is greater and thicker. And if you portray horses
galloping away from the throng, make little clouds of dust
as far distant one from another as is the space between the
strides made by the horse, and that cloud which is farthest

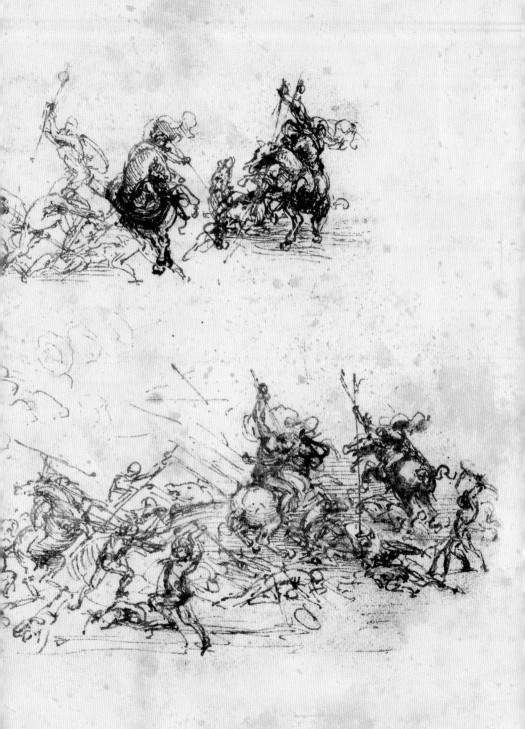

away from the horse should be the least visible, for it should be high and spread out and thin, while that which is nearest should be most conspicuous and smallest and most compact.

Let the air be full of arrows going in various directions, some mounting upwards, others falling, others flying horizontally; and let the balls shot from the guns have a train of smoke following their course. Show the figures in the foreground covered with dust on their hair and eyebrows and such other level parts as afford the dust a space to lodge.

Make the conquerors running, with their hair and other light things streaming in the wind, and with brows bent down; and they should be thrusting forward opposite limbs, that is, if a man advances the right foot, the left arm should also come forward. If you represent anyone fallen you should show the mark where he has been dragged through the dust which has become changed to blood-stained mire, and round about in the half-liquid earth you should show the marks of the trampling of men and horses who have passed over it.

Have a horse dragging the dead body of his master, and leaving behind him in the dust and mud the track of where the body was dragged along.

Depict the beaten and conquered pallid, with brows raised and knit together, and let the skin above the brows be all full of lines of pain; at the sides of the nose show the furrows going in an arch from the nostrils and ending where the eye begins, and show the dilatation of the nostrils which is the cause of these lines; and let the lips be arched displaying the upper row of teeth, and let the teeth be parted after the manner of such as cry in lamentation. Show someone using his hand as a shield for his terrified eyes, turning the palm of it towards the enemy, and having the other resting on the ground to support the weight of his body; let others be crying out with their mouths wide open, and fleeing away. Put all sorts of armour lying between the feet of the combatants, such

as broken shields, lances, swords and other things like these. Show some of the dead half-buried in dust, others with the dust all mingled with the oozing blood and changing into crimson mud; and let the line of the blood be discerned by its colour, flowing in a sinuous stream from the corpse to the dust. Show others in the death agony grinding their teeth and rolling their eyes, with clenched fists grinding against their bodies and with legs distorted. Then you might show one, disarmed and struck down by the enemy, turning on him with teeth and nails to take fierce and inhuman vengeance; and let a riderless horse be seen galloping with mane streaming in the wind, charging among the enemy and doing them great mischief with his hoofs.

You may see there one of the combatants, maimed and fallen on the ground, protecting himself with his shield, and the enemy bending down over him and striving to give him the fatal stroke; there might also be seen many men fallen in a heap on top of a dead horse; and you should show some of the victors leaving the combat and retiring apart from the crowd, and with both hands wiping away from eyes and cheeks the thick layer of mud caused by the smarting of their eyes from the dust.

And the squadrons of the reserves should be seen standing full of hope but cautious, with eyebrows raised, and shading their eyes with their hands, peering into the thick, heavy mist in readiness for the commands of their captain; and so too the captain with his staff raised, hurrying to the reserves and pointing out to them the quarter of the field where they are needed; and you should show a river, within which horses are galloping, stirring the water all around with a heaving mass of waves and foam and broken water, leaping high into the air and over the legs and bodies of the horses; but see that you make no level spot of ground that is not trampled over with blood.

How to Make an Imaginary Animal Appear Natural: Codex Ashburnham, Manuscript 2038, 29 recto

You know that you cannot make any animal without it having its limbs such that each bears some resemblance to that of one of the other animals. If therefore you wish to make one of your imaginary animals appear natural – let us suppose it to be a dragon – take for its head that of a mastiff or setter, for its eyes those of a cat, for its ears those of a porcupine, for its nose that of a greyhound, with the eyebrows of a lion, die temples of an old cock and the neck of a water-tortoise.

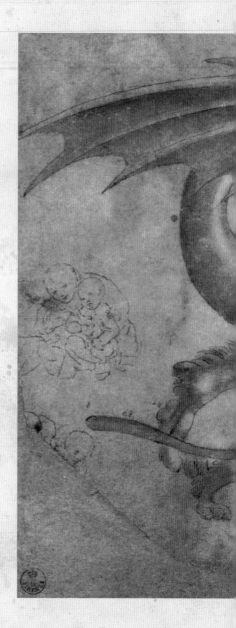

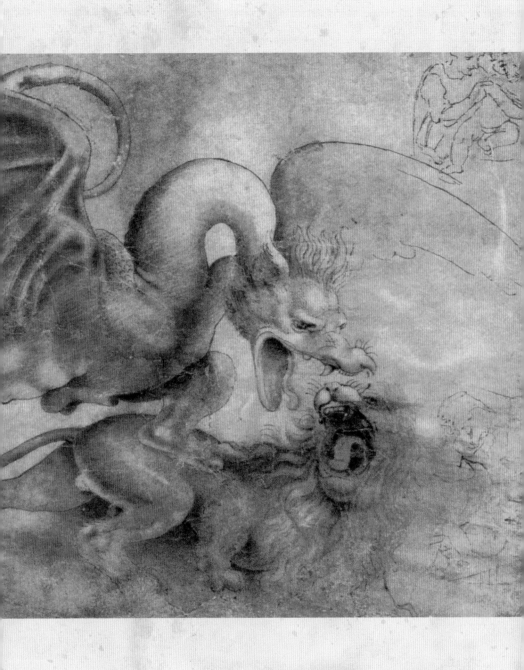

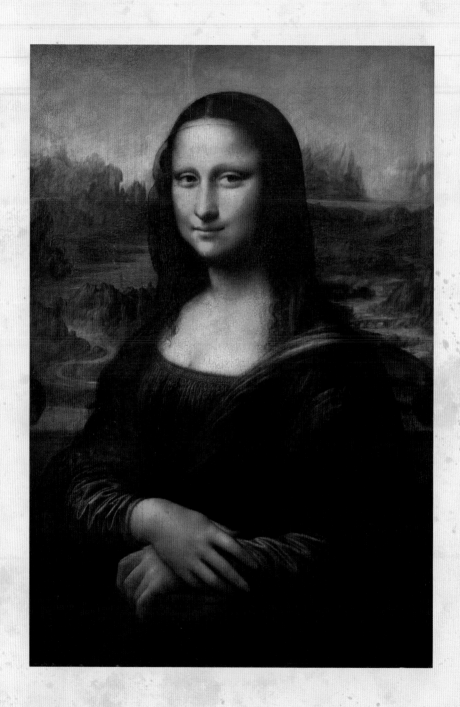

Of the Choice of the Light Which Gives a Grace to Faces: Codex Ashburnham, Manuscript 2038, 20 verso

If you have a courtyard which, when you so please, you can cover over with a linen awning, the light will then be excellent. Or when you wish to paint a portrait, paint it in bad weather, at the fall of the evening, placing the sitter with his back to one of the walls of the courtyard. Notice in the streets at the fall of the evening when it is bad weather the faces of the men and women – what grace and softness they display! Therefore, oh painter, you should have a courtyard fitted up with the walls tinted in black and with the roof projecting forward a little beyond the wall; and the width of it should be ten *braccia*, and the length twenty *braccia*, and the height ten *braccia*; and you should cover it over with the awning when the sun is on it, or else you should make your portrait at the hour of the fall of the evening when it is cloudy or misty, for the light then is perfect.

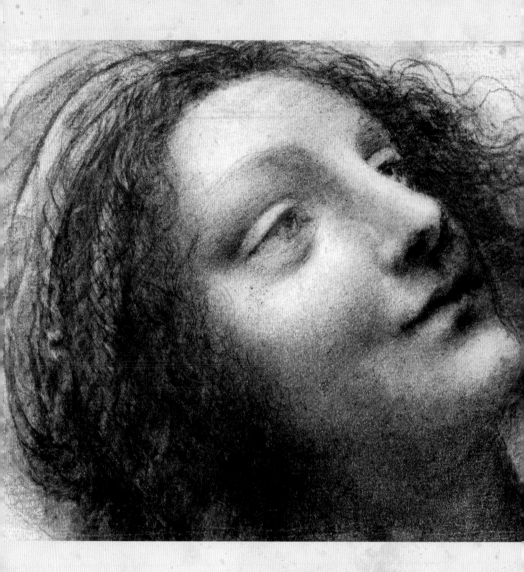

Of the Choice of Beautiful Faces:
Codex Ashburnham, Manuscript 2038, 27 recto

Methinks it is no small grace in a painter to be able to
give a pleasing air to his figures, and whoever is not
naturally possessed of this grace may acquire it by study,
as opportunity offers, in the following manner. Be
on the watch to take the best parts of many beautiful
faces of which the beauty is established rather by
general repute than by your own judgment, for you
may readily deceive yourself by selecting such faces as
bear a resemblance to your own, since it would often
seem that such similarities please us; and if you were
ugly you would not select beautiful faces, but would be
creating ugly faces like many painters whose types often
resemble their master; so therefore choose the beautiful
ones as I have said, and fix them in your mind.

Of the Parts of the Face:
Codex Atlanticus, verso 119 a

If nature had only one fixed standard for the
proportions of the various parts, then the faces of all
men would resemble each other to such a degree that
it would be impossible to distinguish one from another;
but she has varied the five parts of the face in such a
way that although she has made an almost universal
standard as to their size, she has not observed it in the
various conditions to such a degree as to prevent one
from being clearly distinguished from another.

Why a Painting Can Never Appear Detached as Do Natural Things: Codex Ashburnham, Manuscript 2038, 10 recto

Painters oftentimes despair of their power to imitate nature, on perceiving how their pictures are lacking in the power of relief and vividness which objects possess when seen in a mirror, though as they allege they have colours that for clearness and depth far surpass the quality of the lights and shadows of the object seen in the mirror, arraigning herein not reason but their own ignorance, in that they fail to recognise the impossibility of a painted object appearing in such relief as to be comparable to the objects in the mirror, although both are on a flat surface unless they are seen by a single eye. And the reason of this is that when two eyes see one thing after another, as in the case of a [and] b seeing n [and] m, m cannot entirely cover n because the base of the visual lines is so broad as to cause one to see the second object beyond the first. If, however, you close one eye as s, the object f will cover up r, because the visual line starts in a single point and makes its base in the first object, with the consequence that the second, being of equal size, is never seen.

Codex Ashburnham, Manuscript 2038, 12 verso

Every bodily form as far as concerns the function of the eye is divided into three parts, namely substance, shape and colour. The image of its substance projects itself farther from its source than its colour or its shape; the colour also projects itself farther than the shape, but this law does not apply to luminous bodies.

The above proposition is clearly shown and confirmed by experience, for if you see a man near at hand you will be able to recognise the character of the substance of the shape

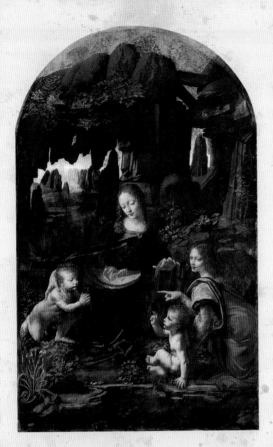

and even of the colour, but if he goes some distance away from you, you will no longer be able to recognise who he is because his shape will lack character, and if he goes still farther away you will not be able to distinguish his colour but he will merely seem a dark body, and farther away still he will seem a very small round dark body. He will appear round because distance diminishes the various parts so much as to leave nothing visible except the greater mass. The reason of this is as follows: we know very well that all the images of objects penetrate to the *imprensiva* through a small aperture in the eye; therefore if the whole horizon d enters through a similar aperture and the object b is a very small part of this horizon, what part must it occupy in the minute representation of so great a hemisphere? And since luminous bodies have more power in darkness than any others, it is necessary, since the aperture of the sight is considerably in shadow, as is the nature of all holes, that the images of distant objects intermingle within the great light of the sky, or if it should be that they remain visible they appear dark and black, as every small body must when seen in the limpidity of the air.

Of How to Represent Someone Who Is Speaking Among a Group of Persons: Codex Ashburnham, Manuscript 2038, 21 recto

When you desire to represent anyone speaking among a group of persons you ought to consider first the subject of which he has to treat, and how so to order his actions that they may be in keeping with this subject. That is, if the subject be persuasive, the actions should serve this intention; if it be one that needs to be expounded under various heads, the speaker should take a finger of his left hand between two fingers of his right, keeping the two smaller ones closed, and let his face be animated and turned towards the people, with mouth slightly opened, so as to give the effect of speaking. And if he is seated let him seem to be in the act of raising himself more upright, with his head forward. And if you represent him standing, make him leaning forward a little with head and shoulders towards the populace, whom you should show silent and attentive, and all watching the face of the orator with gestures of admiration. Show the mouths of some of the old men with the corners pulled down in astonishment at what they hear, drawing back the cheeks in many furrows, with their eyebrows raised where they meet, making many wrinkles on their foreheads; and show some sitting with the fingers of their hands locked together and clasping their weary knees, and others – decrepit old men – with one knee crossed over the other, and one hand resting upon it which serves as a cup for the other elbow, while the other hand supports the bearded chin.

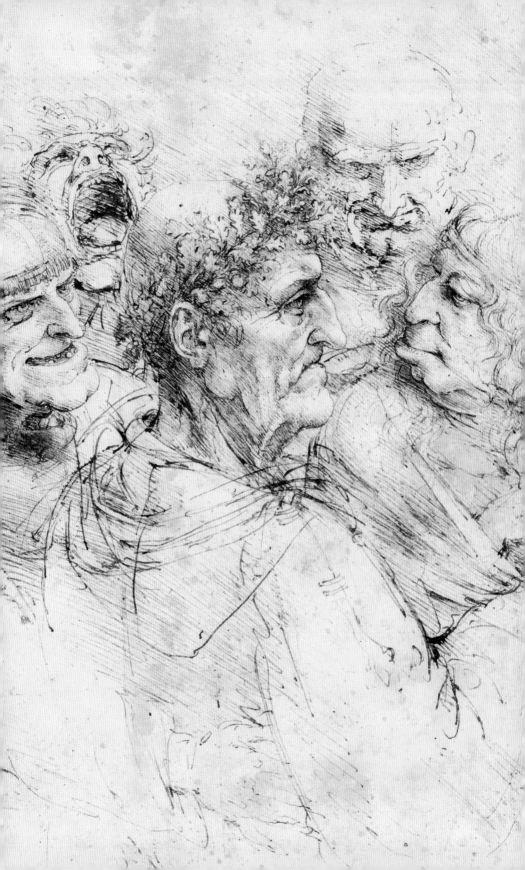

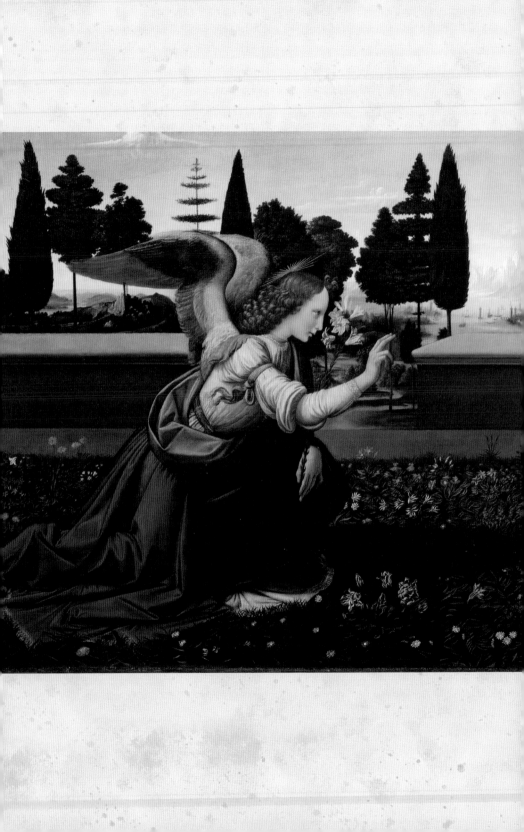

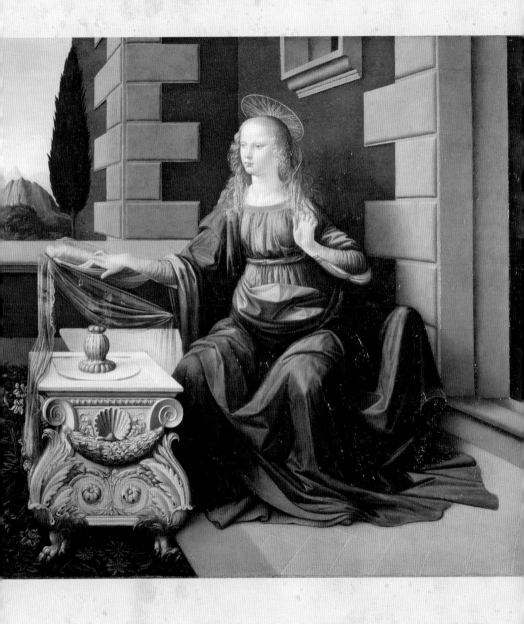

Of Painting: Manuscript G, 23 verso

A very important part of painting consists in the backgrounds of the things painted. Against these backgrounds the contour lines of such natural bodies as possess convex curves will always reveal the shapes of these bodies, even though the colours of the bodies are of the same hue as the background.

This arises from the fact of the convex boundaries of the objects not being illuminated in the same manner as the background is by the same light, because frequently the contours are clearer or darker than the background.

Should, however, these contours be of the same colour as the background, then undoubtedly this part of the picture will interfere with the perception of the figure formed by these contour lines. Such a predicament in painting ought to be avoided by the judgment of good painters, since the painter's intention is to make his bodies appear detached from the background; and in the above-mentioned instance the contrary occurs, not only in the painting but in the objects in relief.

Of the Few Folds in Draperies: Codex Ashburnham, Manuscript 2038, 18 recto

How figures when dressed in a cloak ought not to show the shape to such an extent that the cloak seems to be next to the skin; for surely you would not wish that the cloak should be next to the skin, since you must realise that between the cloak and the skin are other garments which prevent the shape of the limbs from being visible and appearing through the cloak. And those limbs which you make visible, make thick of their kind so that there may seem to be other garments there under the cloak. And you should only allow

the almost identical thickness of the limbs to be visible in
a nymph or an angel, for these are represented clad in light
draperies, which by the blowing of the wind are driven and
pressed against the various limbs of the figures.

Codex Ashburnham, Manuscript 2038, 19 recto, 19 verso and 20 recto

*If you know how to describe and write down the
appearance of the forms, the painter can make them so
that they appear enlivened with lights and shadows which
create the very expression of the faces; herein you cannot
attain with the pen where he attains with the brush.*

How painting surpasses all human works by reason of the
subtle possibilities which it contains: the eye, which is called
the window of the soul, is the chief means whereby the
understanding may most fully and abundantly appreciate
the infinite works of nature; and the ear is the second,
inasmuch as it acquires its importance from the fact that it
hears the things which the eye has seen. If you historians,
or poets, or mathematicians had never seen things with
your eyes you would be ill able to describe them in
your writings. And if you, oh poet, represent a story by
depicting it with your pen, the painter with his brush will
so render it as to be more easily satisfying and less tedious
to understand. If you call painting 'dumb poetry', then the
painter may say of the poet that his art is 'blind painting'.
Consider then which is the more grievous affliction, to
be blind or to be dumb! Although the poet has as wide a
choice of subjects as the painter, his creations fail to afford
as much satisfaction to mankind as do paintings, for while
poetry attempts to represent forms, actions and scenes
with words, the painter employs the exact images of these

forms in order to reproduce them. Consider, then, which is more fundamental to man: the name of man or his image? The name changes with change of country; the form is unchanged except by death.

And if the poet serves the understanding by way of the ear, the painter does so by the eye, which is the nobler sense.

I will only cite as an instance of this how if a good painter represents the fury of a battle and a poet also describes one, and the two descriptions are shown together to the public, you will soon see which will draw most of the spectators, and where there will be most discussion, to which most praise will be given and which will satisfy the more. There is no doubt that the painting, which is by far the more useful and beautiful, will give the greater pleasure. Inscribe in any place the name of God and set opposite to it His image; you will see which will be held in greater reverence!

Since painting embraces within itself all the forms of nature, you have omitted nothing except the names, and these are not universal like the forms. If you have the results of her processes we have the processes of her results.

Take the case of a poet describing the beauties of a lady to her lover and that of a painter who makes a portrait of her; you will see whither nature will the more incline the enamoured judge. Surely the proof of the matter ought to rest upon the verdict of experience!

You have set painting among the mechanical arts! Truly were painters as ready equipped as you are to praise their own works in writing, I doubt whether it would endure the reproach of so vile a name. If you call it mechanical because it is by manual work that the hands represent what the imagination creates, your writers are setting down with the pen by manual work what originates in the mind. If you call it mechanical because it is done for money, who fall into this

error – if indeed it can be called an error – more than you yourselves? If you lecture for the Schools do you not go to whoever pays you the most? Do you do any work without some reward?

And yet I do not say this in order to censure such opinions, for every labour looks for its reward. And if the poet should say, 'I will create a fiction which shall express great things,' so likewise will the painter also, for even so Apelles made the Calumny. If you should say that poetry is the more enduring, to this I would reply that the works of a coppersmith are more enduring still, since time preserves them longer than either your works or ours; nevertheless they show but little imagination; and painting, if it be done upon copper in enamel colours, can be made far more enduring.

In Art we may be said to be grandsons unto God. If poetry treats of moral philosophy, painting has to do with natural philosophy; if the one describes the workings of the mind, the other considers what the mind effects by movements of the body; if the one dismays folk by hellish fictions, the other does the like by showing the same things in action. Suppose the poet sets himself to represent some image of beauty or terror, something vile and foul, or some monstrous thing, in contest with the painter, and suppose in his own way he makes a change of forms at his pleasure, will not the painter still satisfy the more? Have we not seen pictures which bear so close a resemblance to the actual thing that they have deceived both men and beasts?

If you know how to describe and write down the appearance of the forms, the painter can make them so that they appear enlivened with lights and shadows which create the very expression of the faces; herein you cannot attain with the pen where he attains with the brush.

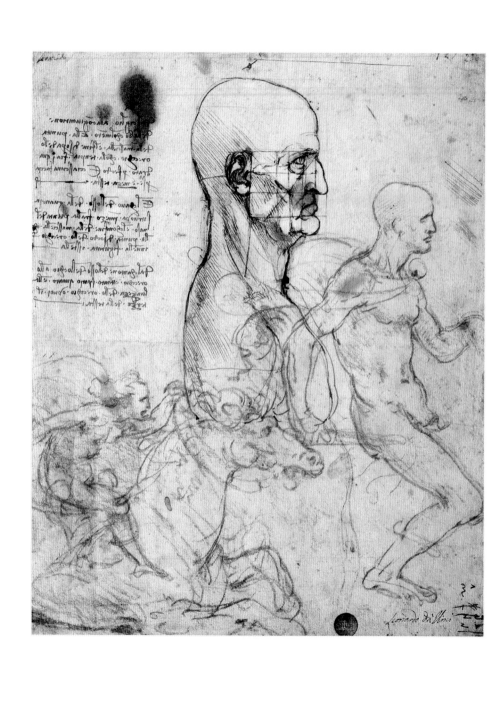

Of the Grace of the Limbs:
Codex Ashburnham, 29 verso

The limbs should fit the body gracefully in harmony
with the effect you wish the figure to produce; and
if you desire to create a figure which shall possess
a charm of its own, you should make it with limbs
graceful and extended, without showing too many of
the muscles, and the few which your purpose requires
you to show indicate briefly, that is without giving
them prominence, and with the shadows not sharply
defined, and the limbs, and especially the arms, should
be easy, that is no limb should be in a straight line with
the part that adjoins it. And if the hips which form as it
were the poles of the man are by his position placed so
that the right is higher than the left, you should make
the top shoulder-joint so that a line drawn from it
perpendicularly falls on the most prominent part of the
hip, and let this right shoulder be lower than the left.

And let the hollow of the throat always be exactly
over the middle of the joint of the foot which is resting
on the ground. The leg which does not support the
weight should have its knee below the other and near
to the other leg.

The positions of the head and arms are numberless,
and therefore I will not attempt to give any rule; it
will suffice that they should be natural and pleasing
and should bend and turn in various ways, with the
joints moving freely so that they may not seem like
pieces of wood.

Manuscript L, 79 recto

It is a necessary thing for the painter, in order to be able to fashion the limbs correctly in the positions and actions which they can represent in the nude, to know the anatomy of the sinews, bones, muscles and tendons in order to know, in the various different movements and impulses, which sinew or muscle is the cause of each movement, and to make only these prominent and thickened, and not the others all over the limb, as do many who in order to appear great draughtsmen make their nudes wooden and without grace, so that it seems rather as if you were looking at a sack of nuts than a human form or at a bundle of radishes rather than the muscles of nudes.

How It Is Necessary for the Painter to Know the Inner Structure of Man: Codex Ashburnham, Manuscript 2038, 27 recto

The painter who has acquired a knowledge of the nature of the sinews, muscles and tendons will know exactly in the movement of any limb how many and which of the sinews are the cause of it, and which muscle by its swelling is the cause of this sinew's contracting, and which sinews having been changed into most delicate cartilage surround and contain the said muscle. So he will be able in diverse ways and universally to indicate the various muscles by means of the different attitudes of his figures; and he will not do like many who in different actions always make the same things appear in the arm, the back, the breast and the legs; for such things as these ought not to rank in the category of minor faults.

Science

*A*natomy, astronomy, optics, geology, engineering and aerodynamics all caught Leonardo's attention. His anatomical drawings, based on his own dissections of cadavers, showed far more advanced understanding of the human body than his peers'. Covering the skeleton, internal organs, nervous system and musculature, his work could have transformed early modern medicine. But it was never published, and only recently rediscovered. He also used mathematics and empirical observation to work extensively on optics, astronomy and bird flight. In many ways, da Vinci was effectively the founder of modern science.

Anatomy

Quaderni d'Anatomia, I, 12 recto

Do this demonstration also as seen from the side, in order to give information as to how much one part may be behind another; and then do one from behind in order to give information as to the veins covered by the spine and by the heart and greater veins.

Your order shall commence with the formation of the child in the womb, saying which part of it is formed first and so on in succession, placing its parts according to the times of pregnancy until the birth, and how it is nourished, learning in part from the eggs which hens make.

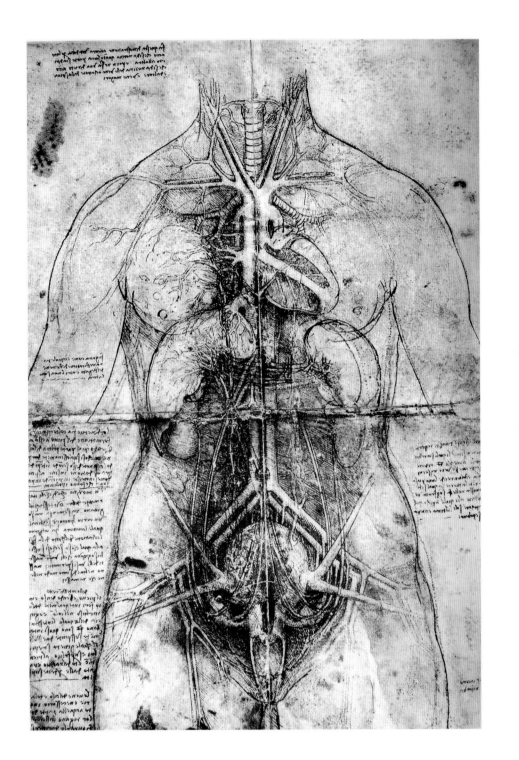

Dell' Anatomia Fogli A, 13 recto

Make a second representation of the bones
in which you will show how the muscles
are fastened to the bones.

Dell' Anatomia Fogli B, 17 verso

And you who say that it is better to look at an anatomical
demonstration than to see these drawings, you would be
right, if it were possible to observe all the details shown in
these drawings in a single figure – in which, with all your
ability, you will not see nor acquire a knowledge of more
than some few veins, while, in order to obtain an exact and
complete knowledge of these, I have dissected more than
ten human bodies, destroying all the various members, and
removing even the very smallest particles of the flesh which
surrounded these veins, without causing any effusion of
blood other than the imperceptible bleeding of the capillary
veins. And as one single body did not suffice for so long a
time, it was necessary to proceed by stages with so many
bodies as would render my knowledge complete; and this I
repeated twice over in order to discover the differences.

But though possessed of an interest in the subject, you
may perhaps be deterred by natural repugnance, or, if this
does not restrain you, then perhaps by the fear of passing the
night hours in the company of these corpses, quartered and
flayed and horrible to behold; and if this does not deter you
then perhaps you may lack the skill in drawing essential for
such representation; and even if you possess this skill it may
not be combined with a knowledge of perspective, while, if
it is so combined, you may not be versed in the methods of
geometrical demonstration or the method of estimating the
forces and strength of muscles, or perhaps you may be found
wanting in patience so that you will not be diligent.

Concerning which things, whether or no they have all
been found in me, the hundred and twenty books which I
have composed will give their verdict 'yes' or 'no'. In these I
have not been hindered either by avarice or negligence but
only by want of time. Farewell.

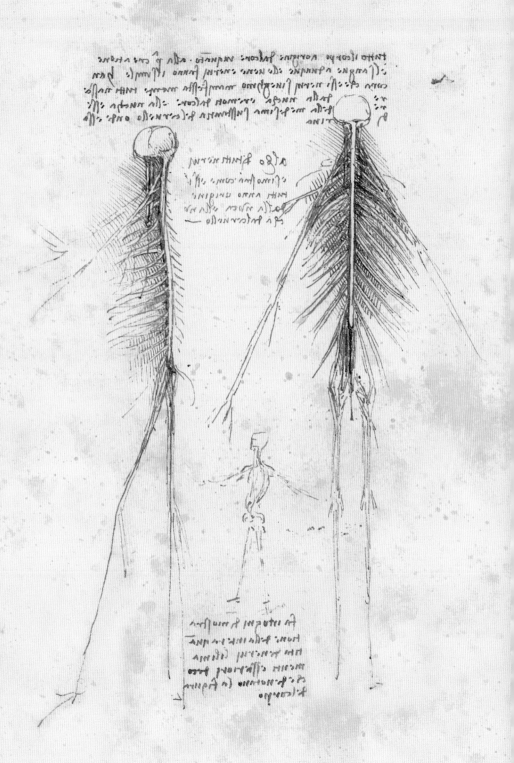

Of the Force of the Muscles: Dell' Anatomia, Fogli B, 3 verso

If any muscle whatsoever be drawn out lengthwise, a slight force will break its fleshy tissue; and if the nerves of sensation be drawn out lengthwise, slight power tears them from the muscles where their ramification weaves them together and spreads and consumes itself; and one sees the same process enacted with the sinewy covering of the veins

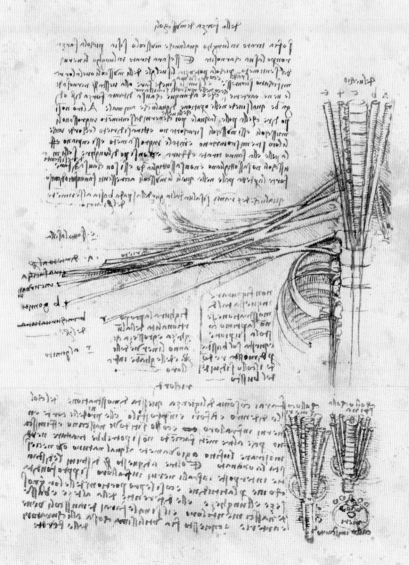

and arteries which are mingled with these muscles. What
is therefore the cause of so great a force of arms and legs
which is seen in the actions of any animal whatsoever?
One cannot say other than that it is the skin which clothes
them; and that when the nerves of sensation thicken the
muscles these muscles contract and draw after them the
tendons in which their extremities become converted;
and in this process of thickening they fill out the skin and
make it drawn and hard; and it cannot be lengthened out
unless the muscles become thinner; and, not becoming
thinner, they are a cause of resistance and of making strong
the before-mentioned skin, in which the swollen muscles
perform the function of a wedge.

[Precepts for demonstrations]
Only represent in this demonstration the first upper rib,
for this of itself suffices to show where the neck is divided
from the bust.

Represent the proportionate length and thickness that
the nerves of the arms and legs have to each other.

[Of the neck]
Use extreme diligence in making this demonstration of
the neck inside, outside and in profile, and the proportions
of the tendons and of the nerves between them, and with
the positions where they begin and end; for if you were
to do otherwise you would neither be able to treat of nor
demonstrate the office or use for which nature or necessity
has intended them. And in addition to this you should
describe the distances interposed between the nerves
themselves, both as regards their depth and breadth, and the
differences in the heights and depths of their origins; and
you will do the like with the muscles, veins and arteries;
and this will be extremely useful to those who have to
dress wounds.

Quaderni d'Anatomia II, 1 recto

With what words, oh writer, can you with a like
perfection describe the whole arrangement of that of
which the design is here?

For lack of due knowledge you describe it so
confusedly as to convey but little perception of the true
shapes of things, and deceiving yourself as to these, you
persuade yourself that you can completely satisfy the
hearer when you speak of the representation of anything
that possesses substance and is surrounded by surface.

I counsel you not to encumber yourself with words
unless you are speaking to the blind. If, however,
notwithstanding you wish to demonstrate in words to
the ears rather than to the eyes of men, let your speech
be of things of substance or natural things, and do not
busy yourself in making enter by the ears things which
have to do with the eyes, for in this you will be far
surpassed by the work of the painter.

How in words can you describe this heart without
filling a whole book? Yet the more detail you
write concerning it, the more you will confuse the
mind of the hearer. And you will always then need
commentators or to go back to experience; and this
with you is very brief, and has to do only with a few
things as compared with the extent of the subject
concerning which you desire complete knowledge.

Quaderni d'Anatomia, III, 10 verso

Represent first all the ramification which
the trachea makes in the lung and then
the ramification of the veins and arteries
separately, and then represent everything
together. But follow the method of
Ptolemy in his *Cosmographia* in the
reverse order: put first the knowledge of
the parts and then you will have a better
understanding of the whole put together.

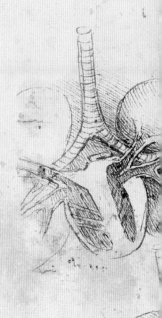

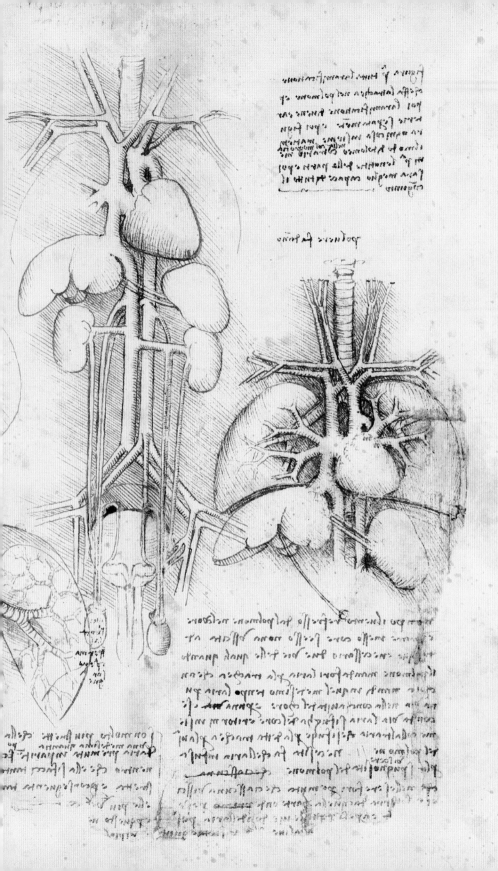

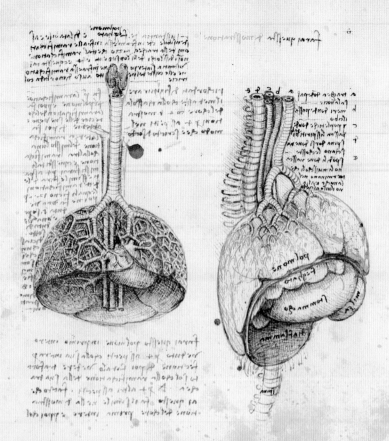

Dell' Anatomia, Fogli B, 37 verso

You will make this demonstration.

Trachea, whence the voice passes.

Oesophagus (*meri*), whence passes the food.

Nerves (*ipopletiche*), whence pass the vital spirits.

Backbone, where the ribs begin.

Vertebrae, whence start the muscles which terminate in the nape of the neck and raise the face towards the sky.

[Precepts for the demonstration of the intestines]
Describe all the heights and breadths of the intestines, and measure them by fingers in halves and thirds of fingers of a dead man's hand, and for all put at what distance they are from the navel, the breasts or the flanks of the dead.

[The relation of the lungs to the bronchial tubes]

The substance of the lung is expansible and extendible, and it is interposed between the ramifications of the trachea, so that these ramifications may not be dislodged from their positions; and this substance interposes itself between this ramification and the ribs of the chest, after the fashion of a soft feather bed.

Remember to represent the mediastinum (heart cavity) with the case of the heart, with four demonstrations, from four aspects, in the manner that is written below.

[How to describe the thoracic organs]

Make first the ramification of the lung, and then make the ramification of the heart, that is of its veins and arteries; afterwards make the third ramification of the mixture of the one ramification with the other; and these mixtures you will make from four aspects, and you will do the like with the said ramifications which will be twelve; and then make a view of each from above and one from below, and this will make in all eighteen demonstrations.

You will first make this lung in its entirety, seen from four aspects, in its entire perfection; afterwards you will represent it so that it is seen perforated merely with the ramification of its trachea in four other aspects.

After you have done this, do the same in the demonstration of the heart, first entire and then with the ramification of its veins and arteries.

Afterwards you will make it seen from four aspects how the veins and arteries of the heart mingle with the ramification of the trachea; then make a ramification of nerves alone from four aspects, and then weave them in four other aspects of the heart and lung joined together; and observe the same rule with the liver and spleen, kidneys, matrix and testicles, brain, bladder and stomach.

Quaderni d' Anatomia III, 3 verso

I reveal to men the origin of
their second – first or perhaps
second – cause of existence.

Through these figures will
be shown the cause of many
dangers of ulcers and diseases.

Division of the spiritual from
the material parts.

And how the child breathes
and how it is nourished through
the umbilical cord; and why one
soul governs two bodies, as when
one sees that the mother desires
a certain food and the child bears
the mark of it.

And why the child [born] at
eight months does not live.

Here Avicenna contends that
the soul gives birth to the soul
and the body to the body and
every member, but he is in error.

Quaderni d'Anatomia III, 8 verso

In the case of this child the heart does not beat and it
does not breathe because it lies continually in water.
And if it were to breathe it would be drowned, and
breathing is not necessary to it because it receives life
and is nourished from the life and food of the mother.
And this food nourishes such creature in just the same
way as it does the other parts of the mother, namely
the hands, feet and other members. And a single soul
governs these two bodies, and the desires and fears and
pains are common to this creature as to all the other
animated members. And from this it proceeds that a
thing desired by the mother is often found engraved
upon those parts of the child which the mother keeps
in herself at the time of such desire; and a sudden fear
kills both mother and child.

We conclude therefore that a single soul governs the
bodies and nourishes the two [bodies].

Dell' Anatomia Fogli B, 40 recto

Where the line a–m intersects the line c–b there will be
the meeting place of all the senses; and where the line
r–n intersects the line h–f there will be the axis of the
cranium in the third of the divisions of the head.

Remember when you represent this half head
from the inside to make another which shall show the
outside turned in the same direction as this, so that you
may better apprehend the whole.

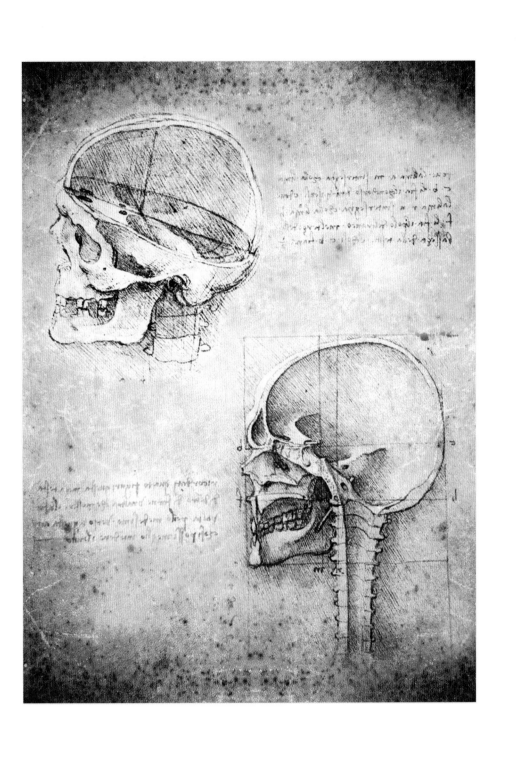

Dell' Anatomia, Fogli B, 41 verso

The concourse of all the senses has below it in a
perpendicular line the uvula where one tastes the food
at a distance of two fingers, and it raises itself above the
tube of the lung and above the orifice of the heart for
the space of a foot; and it has the junction of the bone
of the cranium half a head above it; and it has before it
in a horizontal line at a third of a head away the tear-
duct of the eyes; and behind it it has the nape of the
neck at two-thirds of a head and on the sides the two
pulses of the temples at equal distance and height. The
veins which are shown within the cranium in their
ramification produce an imprint of the half of their
thickness in the bone of the cranium, and the other
half is hidden in the membranes which clothe the
brain; and where the bone has a dearth of veins within
it is replenished from without by the vein a–m , which
after having issued forth from the cranium passes into
the eye and then in the . . .

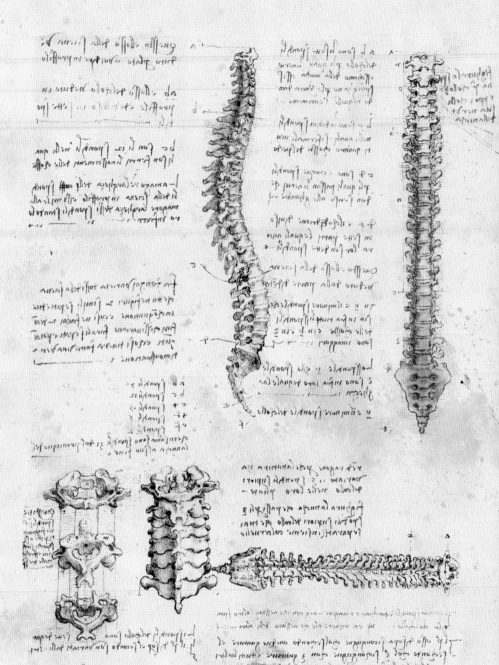

Dell' Anatomia, Fogli A, 8 verso

These three vertebrae should be shown from three aspects as has been done with three from the backbone.

The vertebrae of the neck are seven, of which the first above and the second differ from the other five.

You should make these bones of the neck from three aspects united and from three separated: and so you will afterwards make them from two other aspects, namely seen from below and from above, and in this way you will give the true conception of their shapes, which neither ancient nor modern writers have ever been able to give without an infinitely tedious and confused prolixity of writing and of time.

But by this very rapid method of representing from different aspects, a complete and accurate conception will result, and as regards this benefit which I give to posterity I teach the method of reprinting it in order, and I beseech you who come after me, not to let avarice constrain you to make the prints in . . .

Dell' Anatomia, Fogli A, 4 recto

The neck has four movements, of which the first
consists of raising the second of lowering the face, the
third of turning right or left, the fourth of bending the
head right or left. [. . .] are mixed movements, namely
raising or lowering the face with an ear near to a
shoulder, and similarly raising or lowering the face after
turning it towards one of the shoulders; also raising
or lowering the face after turning it to one of the
shoulders while keeping one eye lower or higher than
the other, and this is called separated movement.

And to these movements should be assigned
the cords and muscles which are the cause of these
movements, and consequently, if a man should be found
lacking in power to make one of these movements as a
result of some wound, one can discern with certainty
which cord or muscle is impeded.

Dell' Anatomia, Fogli B, 10 recto

Draw the arm of Francesco the miniaturist which shows many veins.

[Precepts for anatomical drawings and demonstrations]
In demonstrations of this kind you should show the exact contours of the limbs by a single line; and in the centre place their bones with the true distances from their skin, that is the skin of the arm; and then you will make the veins which may be whole upon a clear ground; and thus there will be given a clear conception as to the position of the bone, vein and nerves.

[Changes of the arteries in age]
In proportion as the veins become old they lose their straightness of direction in their ramifications, and become so much the more flexible or winding and of thicker covering as old age becomes more full with years.

You will find almost universally that the passage of the veins and the passage of the nerves are on the same path, and direct themselves to the same muscles and ramify in the same manner in each of these muscles, and that each vein and nerve pass with the artery between one muscle and the other, and ramify in these with equal ramification.

[Expansibility of the vessels]
The veins are extensible and expansible; and of this there is testimony afforded in the fact that I have seen one who has chanced to wound the common vein and has immediately bound it up again with a tight bandage and in the space of a few days there has grown a blood-coloured tumour as large as a goose's egg, full of blood, and it has remained so for several years; and I have also found in the case of a decrepit man that the mesaraic veins have contracted the passage of the blood and doubled in length.

Dell' Anatomia, Fogli A, 10 recto

The act of procreation and the members employed therein are so repulsive that if it were not for the beauty of the faces and the adornments of the actors and the pent-up impulse, nature would lose the human species.

Arrange it so that the book of the elements of mechanics with examples shall precede the demonstration of the movement and force of man and of the other animals, and by means of these you will be able to prove all your propositions.

Describe how many membranes intervene between the skin and the bones of the hand.

These muscles of the hand may be made first of threads and then according to their true shape.

And they are the muscles that move all the palm of the hand.

When you have represented the bones of the hand and you wish to represent above this the muscles which are joined with these bones, make threads in place of muscles. I say threads and not lines in order to know what muscle passes below or above the other muscle, which thing cannot be shown with simple lines; and after doing this make another hand afterwards at the side of it where there may be the true shape of these muscles as is shown here above.

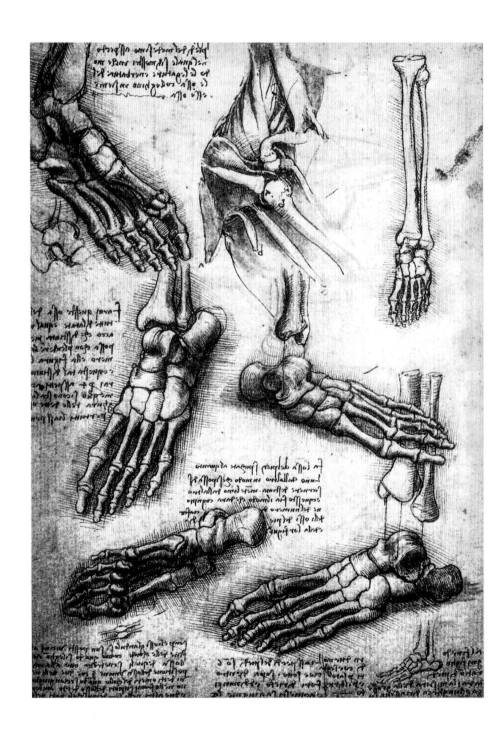

Dell' Anatomia, Fogli A, 12 recto

You will represent these bones of the feet all equally
spread out, in order that their number and shape may
be distinctly understood. And this difference you will
represent from four aspects in order that the true
shape of these bones in all their aspects may be more
accurately known.

Make the bones of the foot somewhat separated
one from another in such a way that one may readily
distinguish one from another, and this will be the means
of imparting the knowledge of the number of the bones
of the feet and of their shape.

At the end of every representation of the feet you
will give the measure of the thickness and length of
each of the bones and its position.

The aspects of the foot are six, namely: below, above,
within, outside, behind and before; and to these is added
the six demonstrations of the separated bones between
them; and there are those of the bones sawn lengthwise
in two ways, that is, sawn through the side and straight
so as to show all the thickness of the bones.

Dell' Anatomia, Fogli A, 18 recto

[Precepts for the study of the foot]
Use the same rule for the foot that you have used for the hand; that is, representing first the bones from six aspects, namely: behind, in front, below and above, on the inside and on the outside.

[Considerations upon the origin of the muscles of the foot]
Mondinus says that the muscles which raise the toes of the feet are to be found in the outer part of the thigh; and then adds that the back of the foot has no muscles because nature has wished to make it light so that it should be easy in movement, as if it had a good deal of flesh it would be heavier; and here experience shows that the muscles abed move the second pieces of the bones of the toes; and that the muscles of the leg r s t move the points of the toes. Here then it is necessary to enquire why necessity has not made them all start in the foot or all in the leg; or why those of the leg which move the points of the toes should not start in the foot instead of having to make a long journey in order to reach these points of the toes; and similarly those that move the second joints of the toes should start in the leg.

[Precepts]
Set down first the two bones of the leg from the knee to the foot, then show the first muscles that start upon the said bones, and proceeding thus you will make one above the other in as many different demonstrations as are the stages in their positions, one above the other; and you will do it thus as far as the end of one side, and you will do the same for four sides in their entirety with all the foot, because the foot moves by means of tendons which start in these muscles of the leg; but the side where is the sole is moved with muscles that start in this sole; and the membranes of the joints of the bones start from the muscles of the thigh and of the leg.

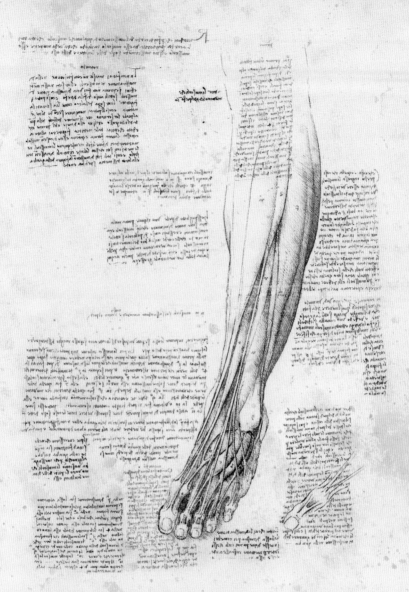

After you have made the demonstration of the bone, show next how it is clothed by those membranes which are interposed between the tendons and these bones.

Remember, in order to make certain as to the origin of each muscle, to pull out the tendon produced by this muscle in such a way as to see this muscle move and its commencement upon the ligaments of the bones.

Avic[enna]. The muscles that move the toes of the feet are sixty.

[By way of note]

You will make nothing but confusion in your demonstration
of the muscles and their positions, beginnings and ends,
unless first you make a demonstration of the fine muscles
by means of threads; and in this way you will be able to
represent them one above another as nature has placed them;
and so you will be able to name them according to the
member that they serve, that is, the mover of the point of
the big toe, and of the middle bone, or the first bone, etc.

And after you have given these details you will show
at the side the exact shape and size and position of each
muscle; but remember to make the threads that denote the
muscles in the same positions as the central lines of each
muscle, and in this way these threads will show the shape of
the leg and their distance in rapid movement and in repose.

[Atrophy of the muscles]

I have stripped of skin one who by an illness had been so
much wasted that the muscles were worn away and reduced
to a kind of thin pellicle, in such a way that the tendons
instead of becoming converted into muscle were transformed
into loose skin; and when the bones were clothed with skin
their natural size was but slightly increased.

**[Topography of the muscles and motor and sensory
nerves of the lower limb]**

You will show first the bones separated and somewhat out
of position, so that it may be possible to distinguish better
the shape of each piece of bone by itself. Afterwards you
join them together in such a way that they do not diverge
from the first demonstration, except in the part which
is occupied by their contact. Having done this, you will
make the third demonstration of those muscles that bind
the bones together. Afterwards you will make the fourth
of the nerves which convey sensation. And then follows

the fifth of the nerves that move or give direction to the
first joints of the toes. And in the sixth you will make
the muscles above the feet where are ranged the sensory
nerves. And the seventh will be that of the veins which
feed these muscles of the foot. The eighth will be that of
the nerves that move the points of the toes. The ninth of
the veins and arteries that are interposed between the flesh
and the skin. The tenth and last will be the completed foot
with all its powers of feeling. You will be able to make the
eleventh in the form of a transparent foot, in which one is
able to see all the aforesaid things.

[Precepts for the study of the leg]
But make first the demonstration of the sensory nerves of
the leg, and their ramification, from four aspects, so that
one may see exactly from whence these nerves have their
origin; and then make a representation of a foot young
and soft with few muscles.

All the nerves of the legs in front serve the points of
the toes, as is shown with the great toe.

[By way of note]
After making your demonstrations of the bones from
various aspects then make the membranes which are
interposed between the bones and the muscles; and in
addition to this, when you have represented the first
muscles, and have described and shown their method of
working, make the second demonstration upon these first
muscles, and the third demonstration upon the second, and
so in succession.

Make here first the simple bones, then clothe them
gradually stage by stage in the same way that nature clothes
them.

When defining the foot it must necessarily be joined with the leg as far as the knee, because in this leg start the muscles which move the points of the toes, that is the final bones.

In the first demonstration the bones should be somewhat separated one from another, in order that their true shape may be revealed. In the second the bones should be shown sawn through, in order that it may be seen what part is hollow and what part solid. In the third demonstration these bones should be joined together. In the fourth should be the ligaments that connect one of these bones with another. In the fifth the muscles that strengthen these bones. Sixth the muscles should be shown with their tendons. Seventh the muscles of the leg with the tendons that go to the toes. Eighth the nerves of sensation. Ninth the arteries and veins. Tenth the muscular skin. Eleventh the foot in its final beauty.

And each of the four aspects should have these eleven demonstrations.

Physical Sciences

Codex Leicester, 1 recto

Memorandum that I have first to show the distance of the sun from the earth and by means of one of its rays passing through a small hole into a dark place to discover its exact dimensions, and in addition to this by means of the sphere of water to calculate the size of the earth.

And the size of the moon I shall discover as I discover that of the sun, that is by means of its ray at midnight when it is at the full.

Manuscript C, 3 recto

That luminous body will appear of less radiance which is surrounded by a more luminous background:

I have found that those stars that are nearest the horizon appear larger in form than the others, because they see and are seen by a greater amount of the solar body than when they are above us; and since they see more of the sun they have a greater light. And the body that is most luminous shows itself of greater form, as the sun shows itself in the mist above us, for it seems larger when it is without mist and with the mist it diminishes.

No part of the luminous body is ever visible from the pyramid of pure derived shadow.

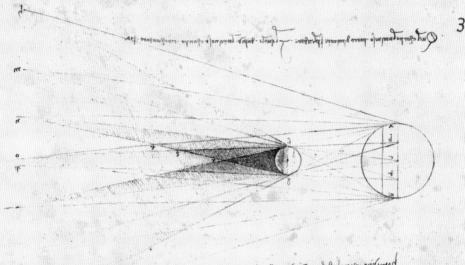

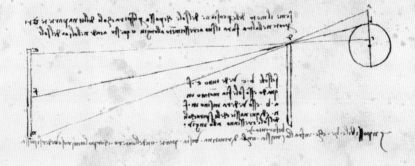

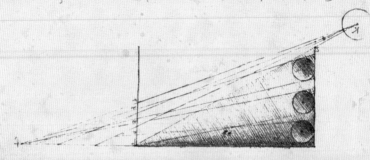

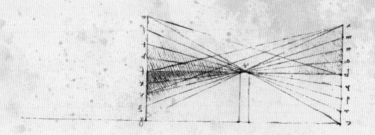

Manuscript C, 5 recto

A luminous body will seem more brilliant when it is surrounded by deeper shadow.

The breadth and length of shadow and light, although through foreshortening they become straighter and shorter, will neither diminish nor increase the quality or quantity of their brightness or darkness.

The function of shadow and of light diminished by foreshortening will be to shade and illumine an object opposite to it, according to the quality and quantity that appear in this object.

The more a derived shadow approaches its penultimate extremities, the deeper it will appear.

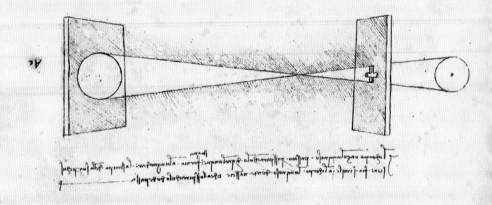

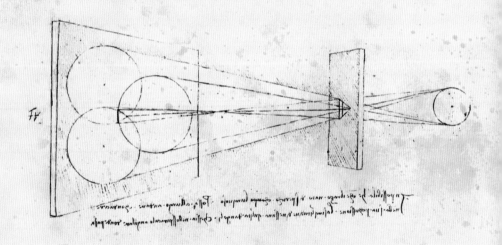

Manuscript C, 10 verso and 11 recto

When a luminous ray has passed through a hole of some unusual shape after a long course, the impression it makes where it strikes resembles the luminous body from which it springs.

It is impossible for the ray born of a luminous spherical body to be able, after a long course, to convey to where it strikes the image of any description of angle that exists in the angular hole through which it passes.

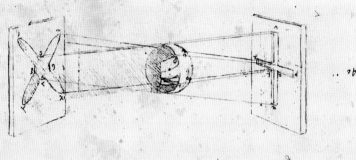

(mirror-script handwritten text)

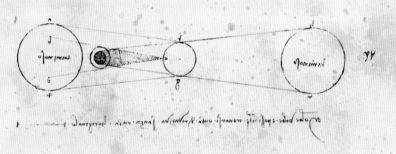

(mirror-script handwritten text)

The shape of the derived
shadow will always conform to
the shape of the original shadow.
A light in the form of a
cross thrown on to a shaded
body of spherical roundness
will produce its shadow in the
figure of a cross.

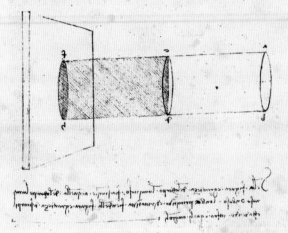

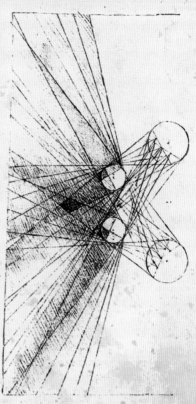

Manuscript E, 18 verso

The shapes of shadows often resemble the shaded body which is their origin, and often the luminous body which is their cause.

If the shape and size of the luminous body are like that of the shaded body, the primitive and derived shadows will have the shape and size of these bodies, falling within equal angles.

The derived shadow at a certain distance will never resemble the shape of the shaded body from which it proceeds, unless the shape of the light from this illuminating body resembles the shape of the body illuminated by the said light.

Light that is long in shape will cause the derived shadow born from a round body to be wide and low, although it makes its percussion between equal angles.

It is impossible that the shape of the derived shadow should resemble that of the shaded body from which it was born, unless the light that causes it is similar in shape and size to this shaded body.

Codex on the Flight of Birds, 8 recto

If the wing and the tail are too far above the wind, lower half the opposite wing and so get the impact of the wind there within it, and this will cause it to right itself.

If the wing and the tail should be beneath the wind, raise the opposite wing and it will right itself as you desire, provided that this wing which rises slants less than the one opposite to it.

And if the wing and the breast are above the wind, it should lower the half of the opposite wing, and this will be struck by the wind and thrown back upwards, and this will cause the bird to right itself.

But if the wing and the spine are below the wind, it ought then to raise the opposite wing and expand it in the wind, and the bird will immediately right itself.

And if the bird is situated with the hinder part above the wind, the tail ought then to be placed beneath the wind, and thus there will be brought about an equilibrium of forces.

But if the bird should have its hinder parts below the wind (raising its tail 2), it should enter with its tail above the wind and it will right itself.

Manuscript E, 22 verso

A bird supporting itself upon the air against the movement
of the winds has a power within itself that desires to
descend, and there is another similar power in the wind that
strikes it which desires to raise it up.

And if these powers are equal one to the other so that
the one cannot conquer the other, the bird will not be able
either to raise or lower itself, and consequently will remain
steady in its position in the air.

This is proved thus: let m be a bird set in the air in the
current of the wind a–b d–c. As this wind strikes it under
the slant of the wing n–f, it comes to make a wedge there
which would bear it upwards and backwards by a slanting
movement if it were not for the opposing power of its
weight, which desires to drop down and forward, as is shown
by its slant g–h, and since powers that are equal to each other
do not subdue but offer a complete resistance the one to
the other, for this reason the bird will neither raise itself nor
lower itself; therefore it will remain steady in its position.

If the bird shown above lowers its wings, it makes
itself more stable upon the air and supports itself with less
difficulty, because it occupies more space by keeping its
wings in a position of equilibrium than in either lowering
or raising its wings. In keeping its wings high, however, it
cannot bend them to either the right or the left with the
same ease that it would if it kept them low. But it is more
certain not to be overturned in keeping its wings high than
in keeping them low and bending them less to the right or
the left, because as it lowers itself on the right side, through
using its tail as a rudder, there is an increase of resistance,
because the wing embraces more air than the other wing
on the side on which it descends abruptly in returning to a
position of equilibrium. Consequently it is a good expedient

to descend with a straight and simple slant, and this it would not be able to do if it held its wings lower than its body, for if it were to bend itself about one of its sides by using its tail as a rudder it would immediately turn upside down, the wing that is farther extended embracing more air and offering more resistance to the slanting descent than the other.

Manuscript E, 23 recto

The extremities of the wings bend much more in pressing the air than when the air is traversed without the beating of the wings.

The simple part of the wing is bent back in the swift slanting descent of the birds. This is proved by the third of this which says: among things which are flexible through the percussion of the air, that will bend most which is longest and least supported by the opposite side.

Therefore the longest feathers of the wings, not being covered by the other feathers that grow behind them and not touching each other from their centre to their tip, will be flexible. And by the ninth of this which said: of things equally flexible, that will bend the most which first opens the air. And this we shall prove by the eleventh which says: of equal and similar things bent by the wind, that will bend the most which is struck by air of greater density.

The helms placed on the shoulders of wings are extremely necessary for it is these parts which keep the bird poised and motionless in the air facing the course of the winds.

This helm a is placed near the spot where the feathers of the wings bend, and through being very strong it bends but little or not at all, being situated in a very strong place and armed with powerful sinews and being itself of hard bone and covered with very strong feathers, one of which serves as a support and protection of the other.

Designs

Leonardo da Vinci's interest in science was extremely practical. His stunning inventions ranged from architectural plans and down-to-earth dredges and hydraulic machines for Milan's canal system, to fanciful flying machines. In each case, his work was meticulous, based on a combination of theory, rigorous observation and testing, and his unique imagination. Scrawled down in his notebooks were thousands of ideas that could change the way people lived. In response to the uncertain times, a good number of these were military creations – designs for weapons and elaborate war machines, along with notes on tactics and strategy.

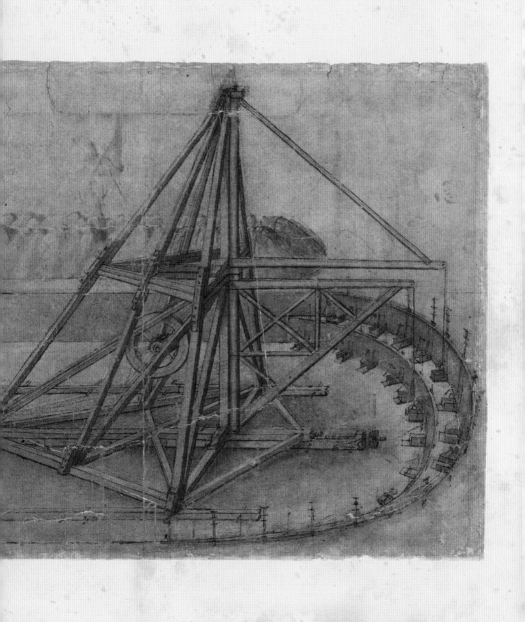

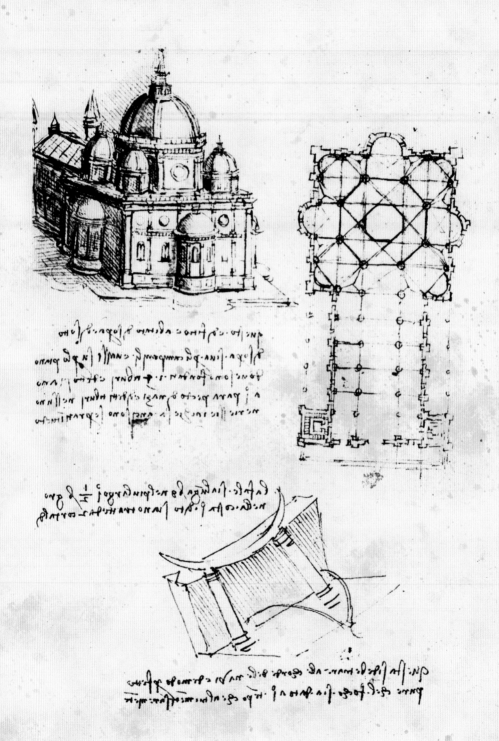

Architecture & Planning

Manuscript B, 24 recto

This edifice is inhabited both in the upper and in
the lower part. The entrance to the upper part is by
way of the campaniles, and it goes along the level
on which rest the four drums of the dome, and the
said level has a parapet in front of it. And none of
these drums communicates with the church but
they are entirely separate.

Manuscript B, 36 recto

Let the street be as wide as the universal height of the houses.

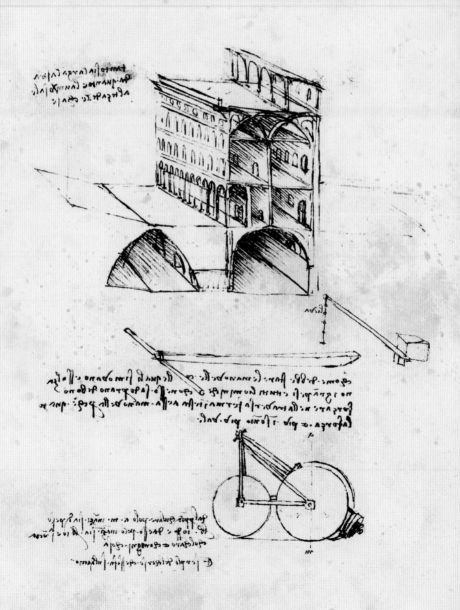

Manuscript B, 57 recto

A represents the upper church of
San Sepolcro at Milan.

B is the part of it below the ground.

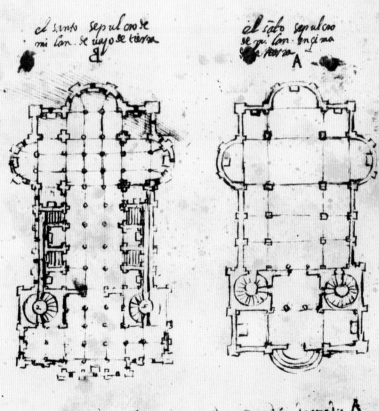

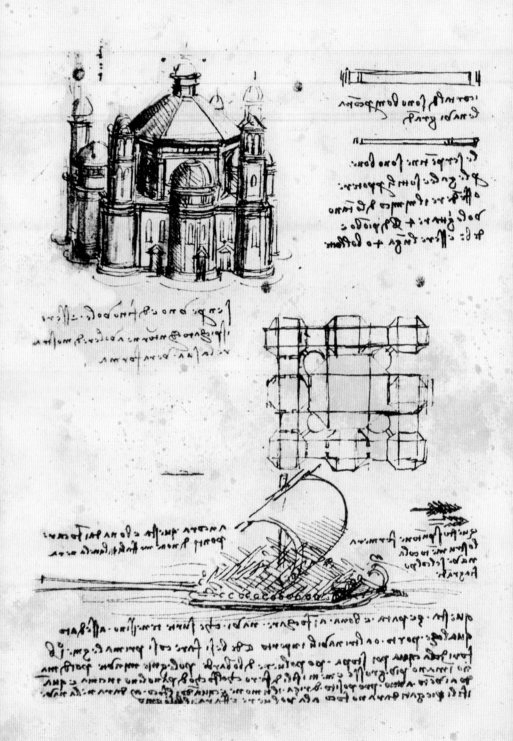

Manuscript B, 39 verso

A building ought always to be
detached all round in order that its
true shape can be seen.

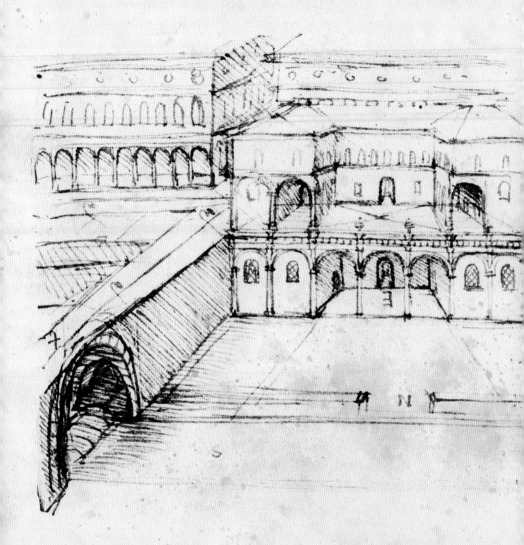

Manuscript B, *15 verso and 16 recto*

The roads [marked] m are six *braccia* higher than the
roads [marked] p [and] s, and each road ought to be
twenty *braccia* wide and have a fall of half a *braccio*
from the edges to the centre. And in this centre at every
braccio there should be an opening one *braccio* long
and of the width of a finger, through which rain-water

may drain off into holes made at the level of the roads p [and] s. And on each side of the extremity of the width of this road there should be an arcade six *braccia* broad resting on columns. And know that if anyone wishes to go through the whole place by the high-level roads, he will be able to use them for this purpose, and so also if anyone wishes to go by the low-level roads.

The high-level roads are not to be used by wagons or vehicles such as these but are solely for the convenience of the gentlefolk. All carts and loads for the service and convenience of the common people should be confined to the low-level roads.

One house has to turn its back on another, leaving the low-level road between them. The doors n serve for the bringing in of provisions such as wood and wine and suchlike things. The privies, the stables and suchlike noisome places are emptied by underground passages, situated at a distance of three hundred *braccia* from one arch to the next, each passage receiving its light through the openings in the streets above. And at every arch there should be a spiral staircase; it should be round because in the corners of square ones, nuisances are apt to be committed. At the first turn there should be a door of entry into the privies and public urinals, and this staircase should enable one to descend from the high-level to the low-level road.

The high-level roads begin outside the gates, and when they reach them they have attained a height of six *braccia*. The site should be chosen near to the sea or some large river, in order that the impurities of the city which are moved by water may be carried far away.

Inventions – Civil

Manuscript B, 80 recto

This man exerts with his head a force that is equal to two hundred pounds, and with his hands a force of two hundred pounds, and this is what the man weighs.

The movement of the wings will be crosswise after the manner of the gait of the horse.

So for this reason I maintain that this method is better than any other.

Ladder for ascending and descending; let it be twelve *braccia* high, and let the span of the wings be forty *braccia*, and their elevation eight *braccia*, and the body from stern to prow twenty *braccia* and its height five *braccia* and let the outside cover be all of cane and cloth.

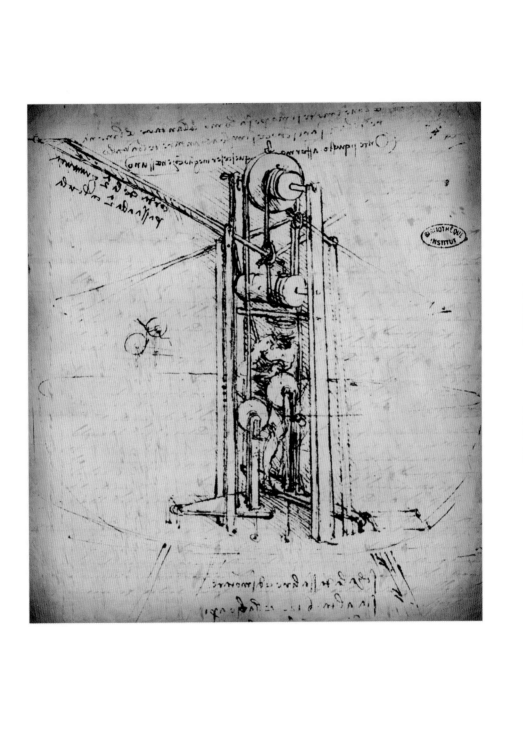

Manuscript B, 89 recto

Make the ladders curved to correspond with the body.

When the foot of the ladder a touches the ground, it cannot give a blow to cause injury to the instrument because it is a cone which buries itself and does not find any obstacle at its point, and this is perfect.

Make trial of the actual machine over water so that if you fall you do not do yourself any harm.

These hooks that are underneath the feet of the ladder act in the same way as when one jumps on the points of one's toes, for then one is not stunned as is the person who jumps upon his heels.

This is the procedure when you wish to rise from an open plain: these ladders serve the same purpose as the legs and you can beat the wings while it is rising. Observe the swift, how when it has settled itself upon the ground it cannot rise flying because its legs are short. But when you have raised yourself, draw up the ladders as I show in the second figure above.

Manuscript B, 74 recto

Device so that when the wing rises
up it remains pierced through and
when it falls it is all united. And in
order to see this it must be looked at
from below.

Make the meshes of this net one
eighth wide.

A should be of immature fir
wood, light and possessing its bark.

B should be fustian pasted there
with a feather to prevent it from
coming off easily.

C should be starched taffeta, and
as a test use thin pasteboard.

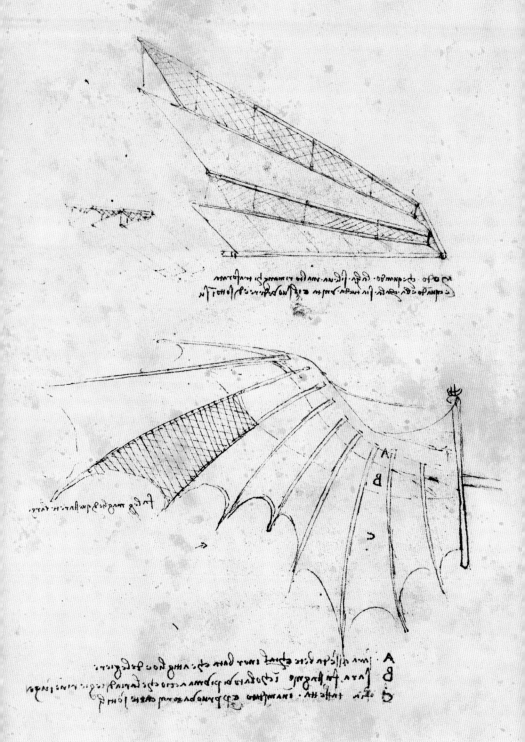

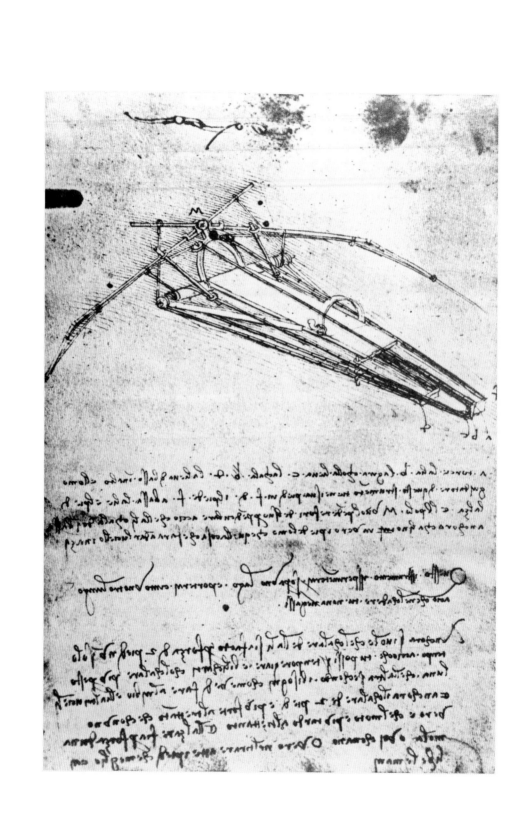

Manuscript B, 74 verso

a twists the wing, b turns it with a lever, c lowers it, d
raises it up, and the man who controls the machine has
his feet at f [and] d; the foot f lowers the wings, and the
foot d raises them.

The pivot M should have its centre of gravity out of
the perpendicular so that the wings as they fall down
also fall towards the man's feet; for it is this that causes
the bird to move forward.

This machine should be tried over a lake, and you
should carry a long wineskin as a girdle so that in case
you fall you will not be drowned.

It is also necessary that the action of lowering the
wings should be done by the force of the two feet at
the same time, so that you can regulate the movement
and preserve your equilibrium by lowering one wing
more rapidly than the other according to need, as
you may see done by the kite and other birds. Also
the downward movement of both the feet produces
twice as much power as that of one: it is true that the
movement is proportionately slower.

The raising is by the force of a spring or if you wish
by the hand, or by drawing the feet towards you, and
this is best for then you will have the hands more free.

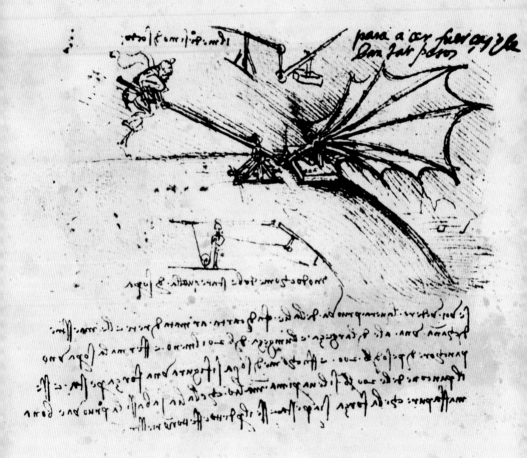

Manuscript B, 88 verso

If you wish to see a real test of the wings, make them of pasteboard covered by net, and make the rods of cane, the wing being at least twenty *braccia* in length and breadth, and fix it over a plank of a weight of two hundred pounds, and make in the manner represented above a force that is rapid; and if the plank of two hundred pounds is raised up before the wing is lowered the test is satisfactory, but see that the force works rapidly, and if the aforesaid result does not follow do not lose any more time.

If by reason of its nature this wing ought to fall in four spaces of time and you by your mechanism cause it to fall in two the result will be that the plank of two hundred pounds will be raised up.

You know that if you find yourself standing in deep water holding your arms stretched out and then let them fall naturally the arms will proceed to fall as far as the thighs and the man will remain in the first position.

But if you make the arms which would naturally fall in four spaces of time fall in two then know that the man will quit his position and moving violently will take up a fresh position on the surface of the water.

And know that if the above-named plank weighs two hundred pounds, a hundred of these will be borne by the man who holds the lever in his hand and a hundred will be carried upon the air by the medium of the wing.

[1] In the drawing the figure of a man is seen working a lever.

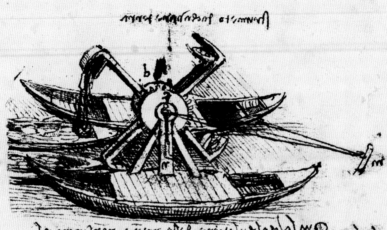

Machine for Excavating Earth: Manuscript E, 75 verso

Here the calculation of the power is not at present fixed.

But you, reader, have to understand that this has a use, which arises by means of the saving of time, which saving springs from the fact that the instrument which conveys the earth up from below is always in the act of carrying it and never turns back. The adversary says that in this case it takes as long to turn round in a useless circle as to turn back at the end of the forward action. But since the additional spaces of time that are interposed between the spaces of useful time are equal in this and in all other inventions, it is necessary to search here for a method whereby the time may be spent in as vigorous and effective a method of work as possible, which will be by inventing a machine that will take more earth; as will be shown on the reverse of this page (see page 128 for illustration).

The winch n as it turns causes a small wheel to revolve, and this small wheel turns the cogged wheel f, and this wheel f is joined to the angle of the boxes which carry the earth from the swamp and discharge themselves upon the barges. But the two cords m–f and m–b revolve round the pole f, and make the instrument move with the two barges against m, and these cords are very useful for this purpose.

The pole is so made as to descend to as great a depth as the wheel has to descend in order to deepen the water of the marsh.

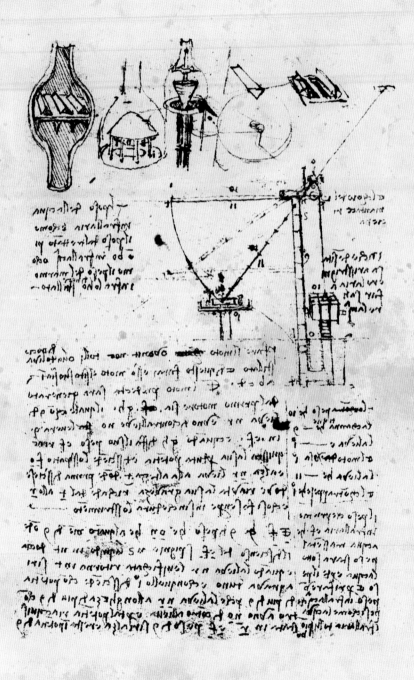

Inventions – Military

Codex Ashburnham, Manuscript 2037, 7 recto (see pages 130–1)

The shields of footsoldiers ought to be of cotton spun into thread and made into cords; these should be woven tightly in a circle after the fashion of a buckler.

And if you so wish the threads should be thoroughly moistened before you make cords of them, and then smeared with the dross of iron reduced to powder.

Then plait it in cords a second time with two, then with four, then with eight, and soak them every time in water with borax or linseed or the seed of quinces. And when you have made your cord, weave the shield. And if you make a doublet, let it be supple, light and impenetrable.

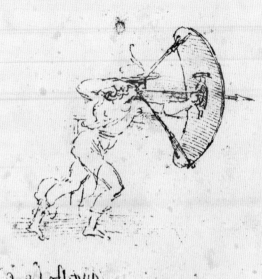

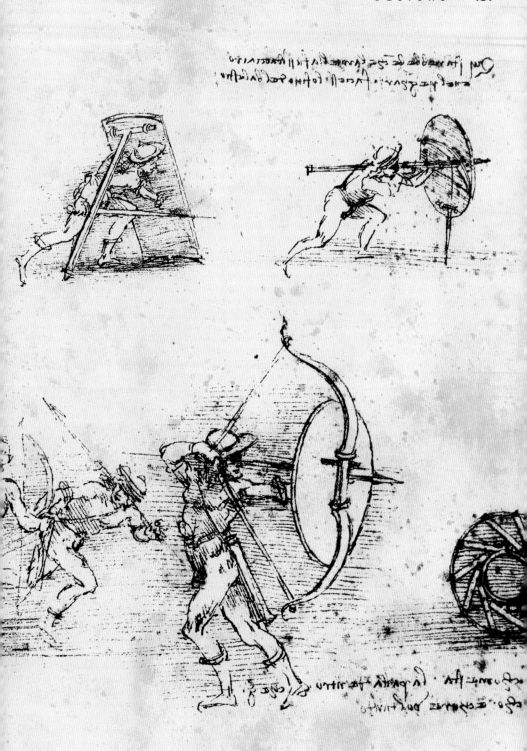

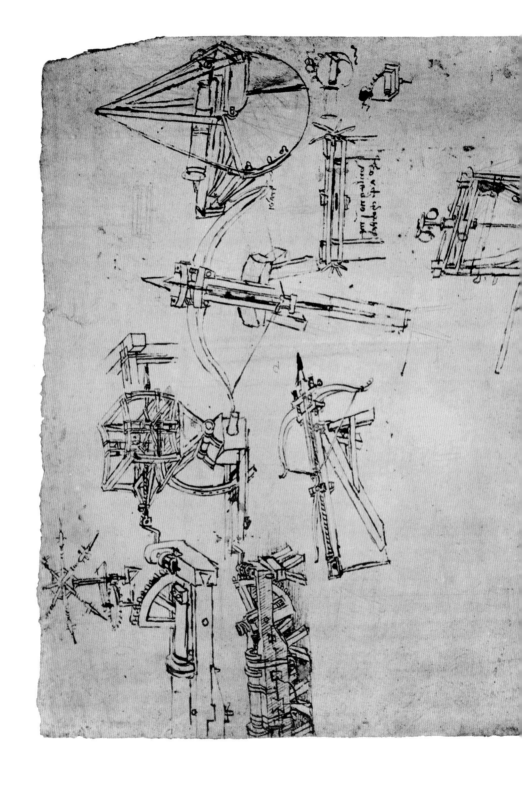

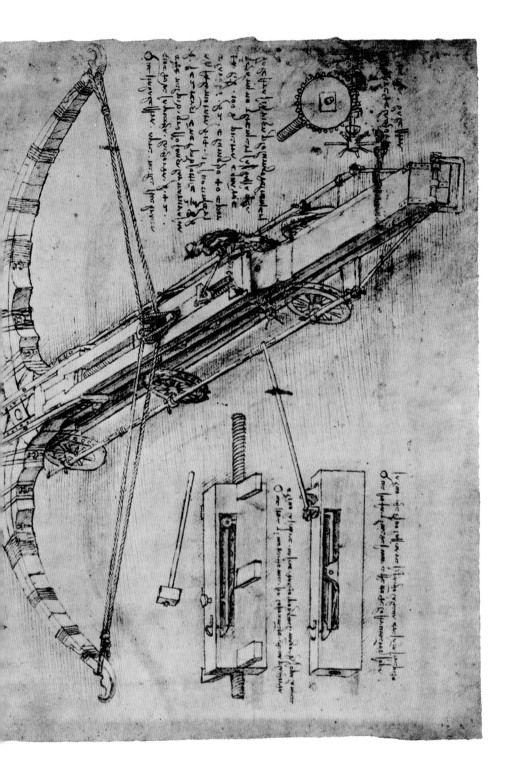

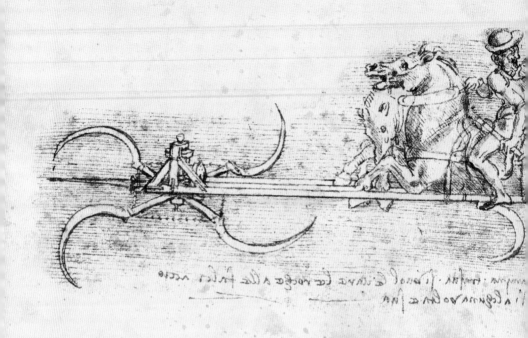

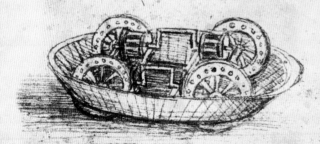

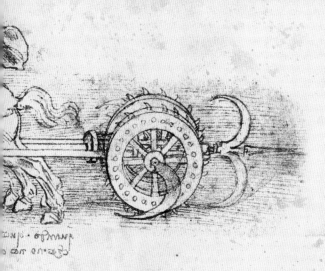

British Museum Drawings, 1860,0616.99

When this is going through its own ranks, it is necessary to raise the machinery that moves the scythes, in order to prevent their doing any harm to anyone.

How the armoured car is arranged inside.

It will need eight men to work it and make it turn and pursue the enemy.

This is good to break through the ranks, but it must be followed up.

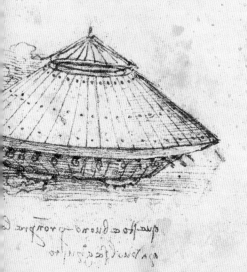

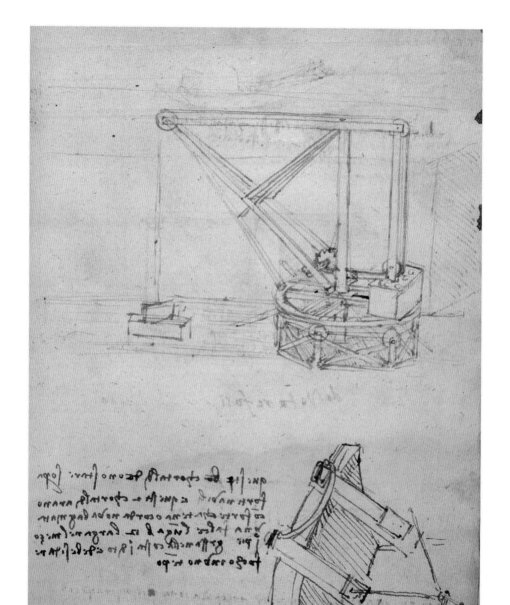

Manuscript B, 49 recto

These cortalds should be placed
upon stout ships, and these two
cortalds will have – fastened by a
strong chain or a new rope soaked
in water – a scythe twelve *braccia*
long and a foot wide at the centre,
and with the back of the blade of
the thickness of a finger; and one
ought to be able to fire both of
them at the same time.

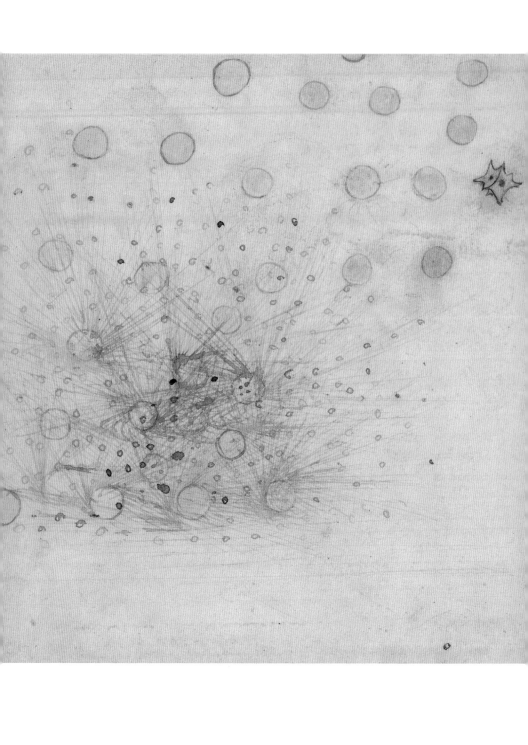

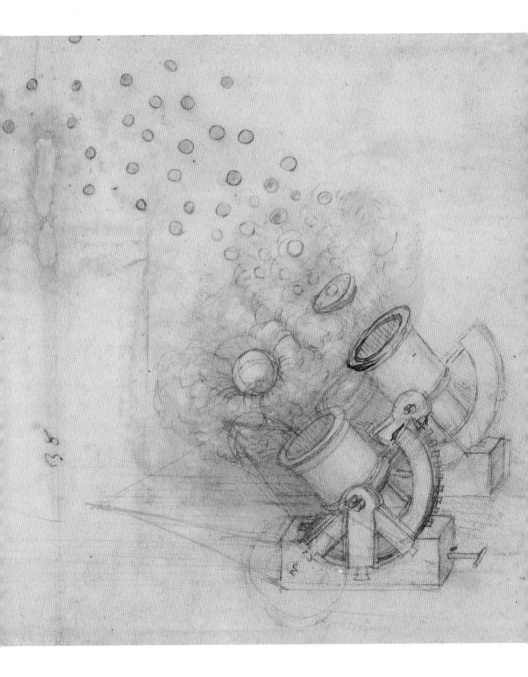

Manuscript B, 30 verso

The *flammea* is a ball put together in this manner: let the following things be boiled together, the ashes of willow, saltpetre, aqua vitae, sulphur, incense and melted pitch with camphor, and a skein of Ethiopian wool which after merely being soaked in this mixture is twisted into the shape of a ball and filled with sharp spikes and thrown on ships with a cord by means of a sling.

This is called Greek fire, and it is a marvellous thing and sets fire to everything under the water. Callimachus the architect was the first to impart it to the Romans, by whom it was afterwards much employed and especially by the Emperor Leo, when the eastern peoples came against Constantinople with an infinite number of ships which were all set on fire by this substance.

Pilocrotho, arzilla, crusida, flammed, lampade although they differ are nevertheless almost of the same substance, and their fire is similar to that spoken of above, that is of the *flammea* except for the addition to the said composition of liquid varnish, oil of petroleum, turpentine and strong vinegar, and these things are first all squeezed together and then left in the sun to dry, and afterwards twisted about a hempen rope and so reduced to a round shape. Afterwards it is drawn with a cord, and some bury the point of a dart in it, transfixing it after having wetted the dart, some bury very sharp nails within it; and a hole is left in the said ball or mass for the purpose of setting it on fire and all the rest of it is smeared with resin and sulphur. Our forefathers made use of this compound pressed tightly together and bound to the end of a spear, in order to ward off and resist the impetuous fury of the enemy ships.

Lucan says that Caesar used to make this fire in order to throw it by means of lamps upon the ships of the Cerusci, a people of Germany; he burnt not merely the said ships, but the buildings constructed upon the borders of the sea were consumed by a similar fire.

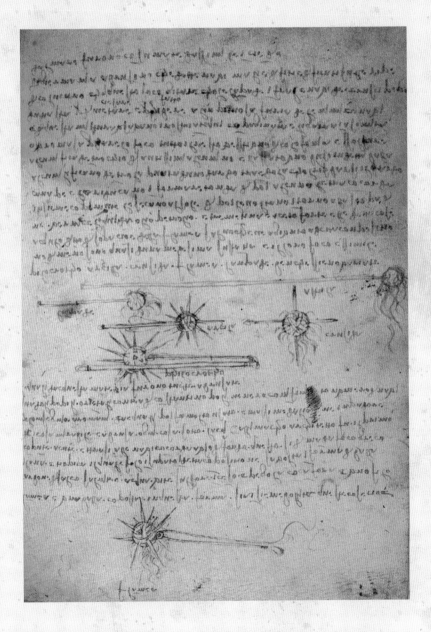

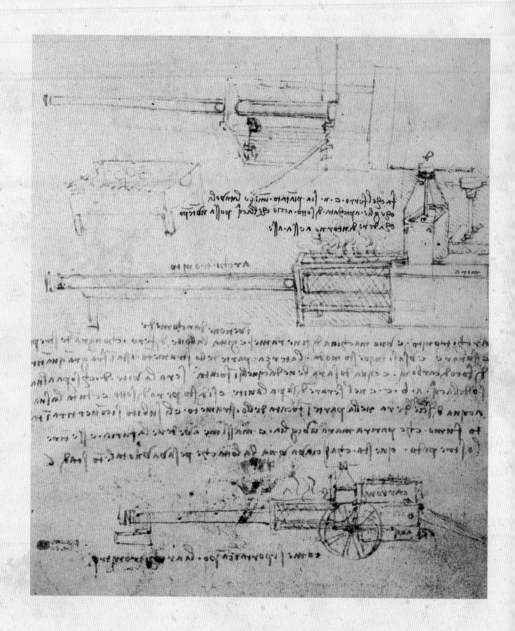

Manuscript B, 33 recto

The *architronito* is a machine of fine copper, an invention of Archimedes, and it throws iron balls with a great noise and fury. It is used in this manner: the third part of the instrument stands within a great quantity of burning coals and when it has been thoroughly heated by these it tightens the screw d which is above the cistern of water a b c; and as the screw above becomes tightened it will cause that below to become loosened. And when consequently the water has fallen out it will descend into the heated part of the machine, and there it will instantly become changed into so much steam that it will seem marvellous, and especially when one sees its fury and hears its roar. This machine has driven a ball weighing one talent six stadia.

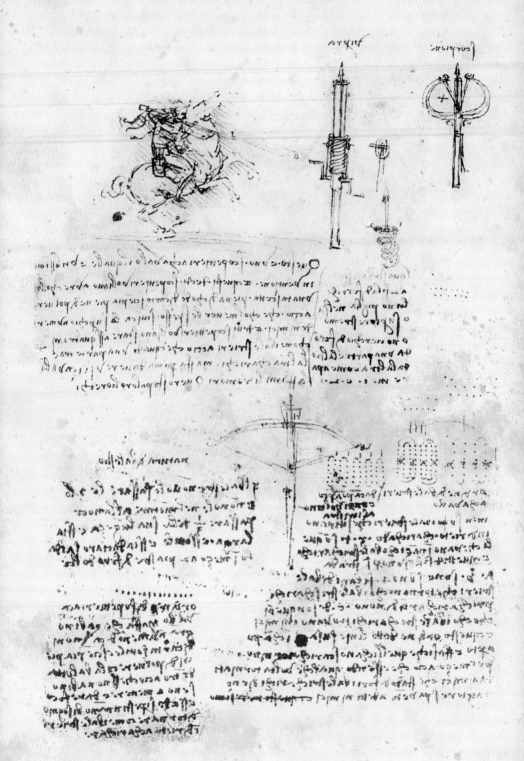

Manuscript B, 46 verso

This is a mounted carabineer which is an extremely
useful invention. The said carabineers should be
provided with pouches full of rolls of plain paper filled
with powder, so that by frequently inserting them
they subdue the excessive numbers of the enemy. And
these carabineers should stand in squadrons as do cross-
bowmen, so that when one part fires, the other loads;
but first make sure that you have accustomed the horses
to such noises; or else stop up their ears.

Order of mounted cross-bowmen on the open field:
m n are crossbowmen who as they turn left draw back
loading, r t are those who go forward with cross-bows
loaded, and these four files are for one route; a b are four
files of cross-bowmen who turn with bows unloaded in
order to load them anew; c d are those who come upon
the enemy with their bows loaded; and this arrangement
of eight lines is employed in open field.

And have it so that those who have unloaded come
through the centre, so that if sometimes they have been
routed by the enemy, the cross-bowmen who are loaded,
holding themselves on the flanks, may cause greater fear
to these same enemies.

Order of mounted carabineers: —
See that they are well supplied with guns with a thin
single fold of paper filled with powder with the ball
within, so that they have only to put it in and set alight.
Being thus ready they will have no need to turn as have
the cross-bowmen when they are preparing to load.

Manuscript B, 83 verso

These take the place of the elephants. One may tilt
with them. One may hold bellows in them to spread
terror among the horses of the enemy, and one may put
carabineers in them to break up every company.

Let the outer extremity of the screw be of steel wire
as thick as a cord, and from the circumference to the
centre let it be eight *braccia*.

I find that if this instrument made with a screw
be well made – that is to say, made of linen of which
the pores are stopped up with starch – and be turned
swiftly, the said screw will make its spiral in the air and
it will rise high.

Take the example of a wide and thin ruler whirled
very rapidly in the air, you will see that your arm will
be guided by the line of the edge of the said flat surface.

The framework of the above-mentioned linen
should be of long stout cane. You may make a small
model of pasteboard, of which the axis is formed of fine
steel wire, bent by force, and as it is released it will turn
the screw.

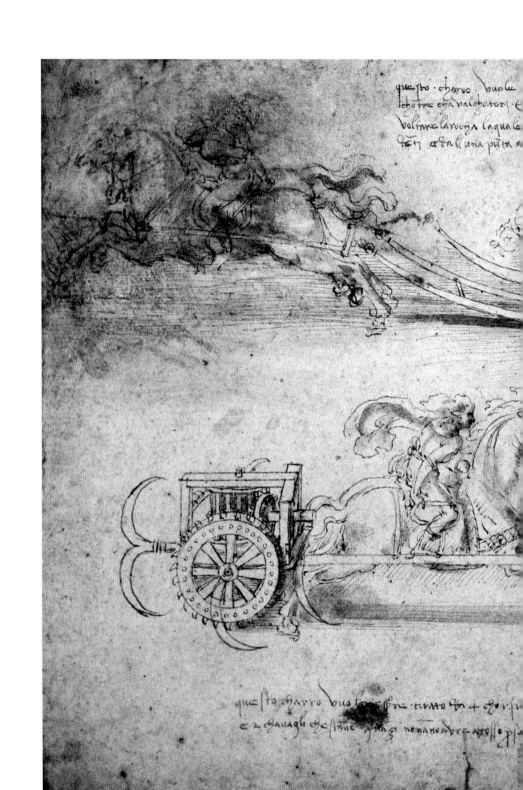

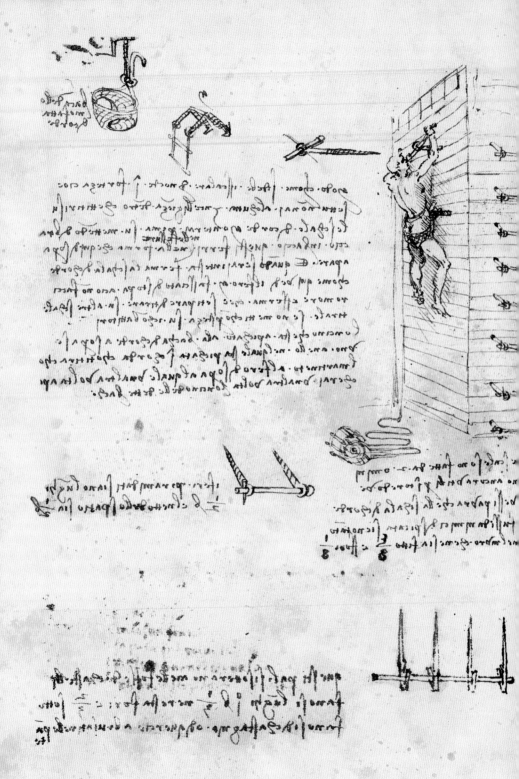

How to Scale a Fortress by Night: Manuscript B, 59 verso

If you have not any information from within as to who will draw up the rope-ladders, you will ascend first by placing these irons in the crevices a *braccio*'s space apart in the manner shown above.

And when you are at the top, fix the rope-ladder where you see here the iron m; let it be bound with tow so that you do not make any sound, and there remain. Then if it should seem that you ought to draw up other ladders, do so; if not, cause the assailants to ascend quickly. The hook which is attached to a brace of ropes has above it a ring to which is fixed a rope, and this is drawn up by a jack to the iron above, and to this you attach a second time the hook of the above-mentioned braces.

These ladders are made to carry two men. They are also useful for a tower where you are afraid lest the rope-ladder may be detached by the enemy; they should be driven so far into the wall that three eighths [of a *braccio*] is buried and one eighth is free. These pyramidal irons should be half a *braccio* in length and their distance apart half a *braccio*.

Manuscript B, 78 recto

Rod filled with rockets for encountering the enemy at
the outlet of a subterranean gallery [that opens] from
below upwards, which will clear the ground of the men
within the entrance.

Rod with rockets for placing in a gallery that leads
into a cellar which would be in a fortress and would be
well guarded.

m a b. The way of a winding gallery that will deceive
the enemy when besieged.

We can clearly understand that all those who find
themselves besieged employ all those methods which are
likely to lead to the discovery of the secret stratagems
of the besieger. You therefore who seek by subterranean
ways to accomplish your desire, reflect well how your
enemy will be on the alert, and how if you should make
a gallery on one side he will make a trench up to your
[gallery], and this will be well guarded by day and by
night, for it will be supposed that the secret way, as is
natural, has its outlet in the said gallery.

When therefore by your digging operations you show
that you wish to come out in one particular spot, and
by making the circuit of the fortress you come out at
the opposite side, as it is shown above in m b a, b will be
when you are almost at the outlet in a cellar that is a. You
will have a great reserve of men who on the breaking of
the wall that is between you and the cellar . . .

When you have made your gallery almost to its end
and it is near to a cellar, break through suddenly and
then thrust this [rod] in front of you filled with rockets
if you find defenders there, but if not, do not set fire to
them lest you make a noise.

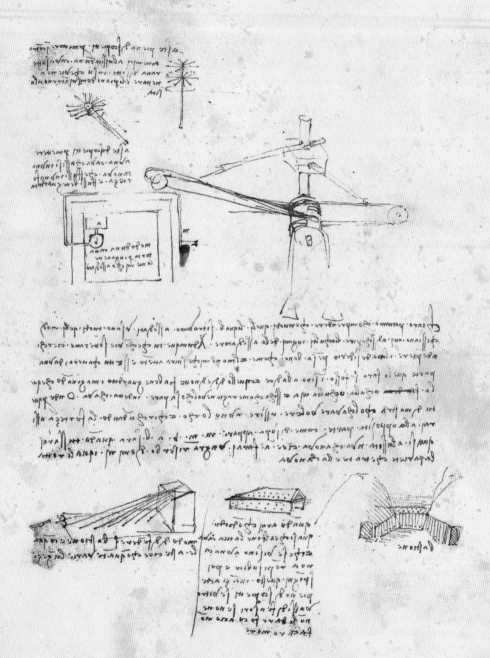

Further Reading

Clayton, Martin & Philo, Ron, *Leonardo da Vinci: Anatomist*, Royal Collection Trust, London, 2012

Clayton, Martin & Philo, Ron, *Leonardo da Vinci: The Divine and the Grotesque*, Royal Collection Trust, London, 2002

Clayton, Martin & Philo, Ron, *Leonardo da Vinci: The Mechanics of Man*, Royal Collection Trust, London, 2010

Kemp, Martin, *Leonardo da Vinci: Experience, Experiment and Design*, V & A Publishing, London, 2009

Kemp, Martin, *La Bella Principessa: The Story of the New Masterpiece by Leonardo da Vinci*, Hodder & Stoughton, London, 2010

Kemp, Martin, *Leonardo da Vinci: The Marvellous World of Nature and Man*, Oxford University Press, Oxford, 2007

Landrus, Matthew, *Leonardo da Vinci's Giant Crossbow*, Springer-Verlag, Berlin, 2010

Landrus, Matthew, *The Treasures of Leonardo da Vinci*, Andre Deutsch, London, 2006

Marani, Pietro C. & Fiorio, Maria Teresa, *Leonardo da Vinci: The Design of the World, 1452–1519*, Skira Editore, Milan, 2015

Nathan, Johannes & Zollner, Frank, *Leonardo da Vinci: Complete Paintings and Drawings*, Taschen, Berlin, Hong Kong, London, New York, Paris, 2015

Nicholl, Charles, *Leonardo da Vinci: The Flights of the Mind*, Penguin, New York, London, 2004

Suh, H. Anna, *Leonardo's Notebooks*, Black Dog & Leventhal, New York, 2005

Vinci, Leonardo da, Brown, John William & Nicholas Poussin (illus.), *A Treatise on Painting: Leonardo da Vinci, Life of Leonardo and an Account of His Life*, Prometheus Books, London 2002

Vinci, Leonardo da, *On the Human Body*, Dover Publications, London, 1984

Index

Picture Credits

Shutterstock: 55, 73, 82, 102-3, 119, 130-1, 132-3 (Everett Historical)

Getty: 18 (De Agostini Picture Library), 26 (De Agostini Picture Library), 29 (De Agostini Picture Library), 36 (De Agostini Picture Library), 48 (De Agostini Picture Library), 100 (De Agostini Picture Library), 108 (Fratelli Alinari IDEA S.p.A./Corbis Historical), 111 (Fratelli Alinari IDEA S.p.A./Corbis Historical), 112 (Fratelli Alinari IDEA S.p.A./Corbis Historical), 115 (Fratelli Alinari IDEA S.p.A./Corbis Historical), 120 (DEA Picture Library), 126 (DEA Picture Library), 134-5 (DEA Picture Library)

Bridgeman Images: 20-1 (Preparatory drawing for the Last Supper (sepia ink on linen paper), Vinci, Leonardo da (1452-1519) / Galleria dell'Accademia, Venice, Italy), 32-3 (Fight between a Dragon and a Lion (brown ink with wash on paper), Vinci, Leonardo da (1452-1519) / Gabinetto dei Disegni e Stampe, Galleria Degli Uffizi, Florence, Italy), 41 (A man tricked by gypsies, c.1493 (pen & ink on paper), Vinci, Leonardo da (1452-1519) / Royal Collection Trust © Her Majesty Queen Elizabeth II, 2017), 58 (The nervous system, c.1508 (pen & ink on paper), Vinci, Leonardo da (1452-1519) / Royal Collection Trust © Her Majesty Queen Elizabeth II, 2017), 60 (The brachial plexus, c.1508 (pen & ink over chalk on paper), Vinci, Leonardo da (1452-1519) / Royal Collection Trust © Her Majesty Queen Elizabeth II, 2017), 63 (Studies of the heart and pulmonary vessels, c.1511 (pen & ink over chalk on paper), Vinci, Leonardo da (1452-1519) / Royal Collection Trust © Her Majesty Queen Elizabeth II, 2017), 64-5 (The Heart, lungs and other organs, c.1508 (pen & ink over black chalk on paper), Vinci, Leonardo da (1452-1519) / Royal Collection Trust © Her Majesty Queen Elizabeth II, 2017), 66 (Study of the thoracic and abdominal organs, c.1508 (pen & ink over chalk on paper), Vinci, Leonardo da (1452-1519) / Royal Collection Trust © Her Majesty Queen Elizabeth II, 2017), 76 (The vertebral column, c.1510 (pen & ink with wash, over traces of black chalk on paper), Vinci, Leonardo da (1452-1519) / Royal Collection Trust © Her Majesty Queen Elizabeth II, 2017), 81 (The veins of the arm, c.1508 (pen & ink over chalk on paper), Vinci, Leonardo da (1452-1519) / Royal Collection Trust ©

Her Majesty Queen Elizabeth II, 2017), 87 (The muscles and tendons of the lower leg and foot, c.1510 (pen & ink, over traces of black chalk on paper), Vinci, Leonardo da (1452-1519) / Royal Collection Trust © Her Majesty Queen Elizabeth II, 2017), 90 (Studies of the Illumination of the Moon, fol. 1r from Codex Leicester, c.1506-08 (pen & ink on paper), Vinci, Leonardo da (1452-1519) / Private Collection / Photo © Christie's Images), 106-7 (Crane, excavator, from Atlantic Codex (Codex Atlanticus) by Leonardo da Vinci, folio 4 recto, Vinci, Leonardo da (1452-1519) / Biblioteca Ambrosiana, Milan, Italy / De Agostini Picture Library), 124 (MS B 2173, folio 74v: Study for a flying machine, 1487-1490 (pen & ink on paper), Vinci, Leonardo da (1452-1519) / Bibliotheque de l'Institut de France, Paris, France), 128-9 (Design for a dredger and various hydraulic machines, fol. 75v and 76r from Paris Manuscript E, 1513-14 (pen and ink on paper), Vinci, Leonardo da (1452-1519) / Bibliotheque de l'Institut de France, Paris, France), 138-9 (Mortar from Atlantic Codex (Codex Atlanticus) by Leonardo da Vinci, folio 31 recto, Vinci, Leonardo da (1452-1519) / Biblioteca Ambrosiana, Milan, Italy / De Agostini Picture Library)

123rf: 56 (Karel Miragaya), 74 (Karel Miragaya), 78 (Karel Miragaya), 84 (Karel Miragaya)

RMN: 93 (Photo (C) RMN-Grand Palais (Institut de France) / Thierry Le Mage), 94 (Photo (C) RMN-Grand Palais (Institut de France) / Thierry Le Mage), 96-7 (Photo (C) RMN-Grand Palais (Institut de France) / René-Gabriel Ojéda), 98-9 (Photo (C) RMN-Grand Palais (Institut de France) / René-Gabriel Ojéda), 116 (Photo (C) RMN-Grand Palais (Institut de France) / Agence Bulloz), 123 (Photo (C) RMN-Grand Palais (Institut de France) / Agence Bulloz), 136 (Photo (C) RMN-Grand Palais (Institut de France) / Agence Bulloz), 141 (Photo (C) RMN-Grand Palais (Institut de France) / Gérard Blot), 142 (Photo (C) RMN-Grand Palais (Institut de France) / Gérard Blot), 144 (Photo (C) RMN-Grand Palais (Institut de France) / René-Gabriel Ojéda), 153 (Photo (C) RMN-Grand Palais (Institut de France) / René-Gabriel Ojéda)